Ninja Pants Files
Vol. 1
By
Adam Ferrill

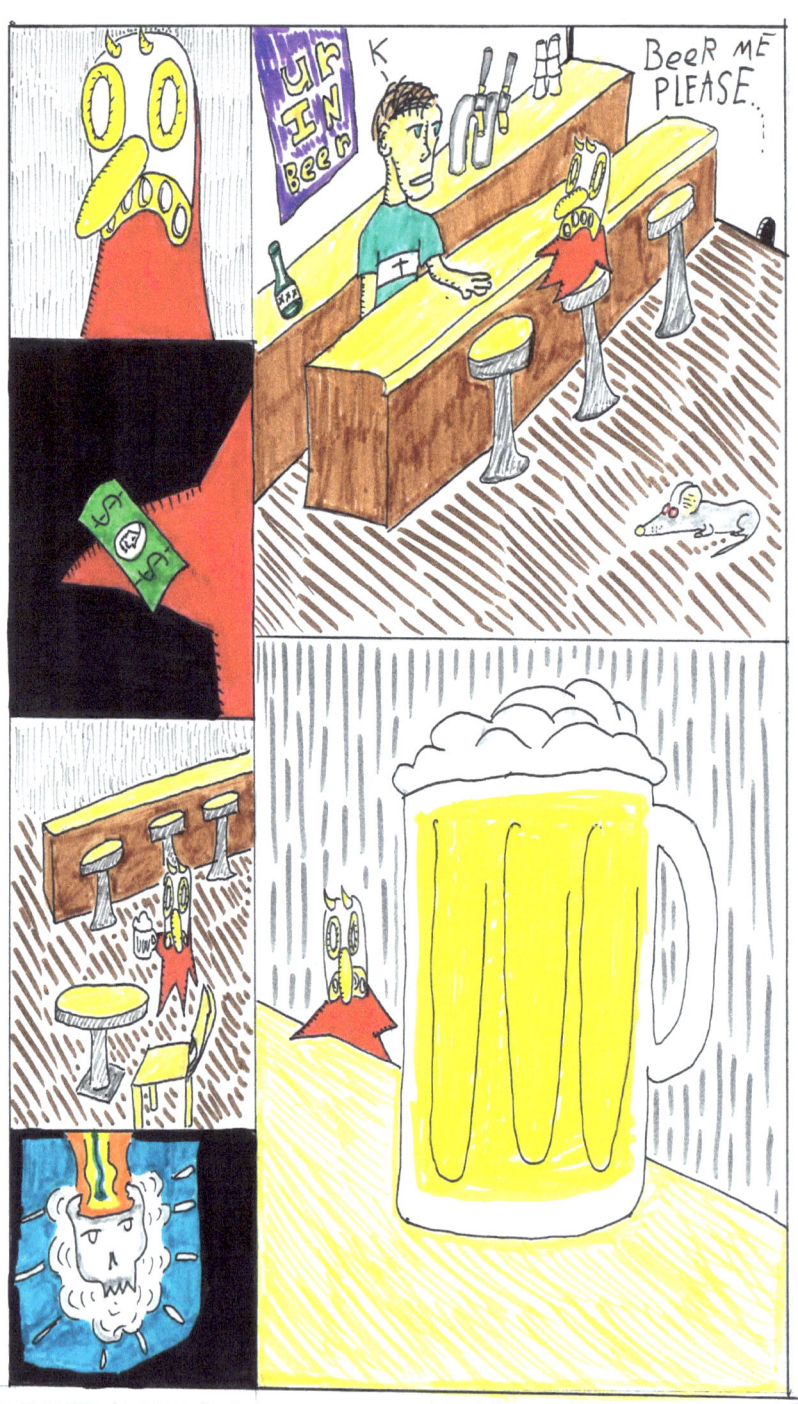

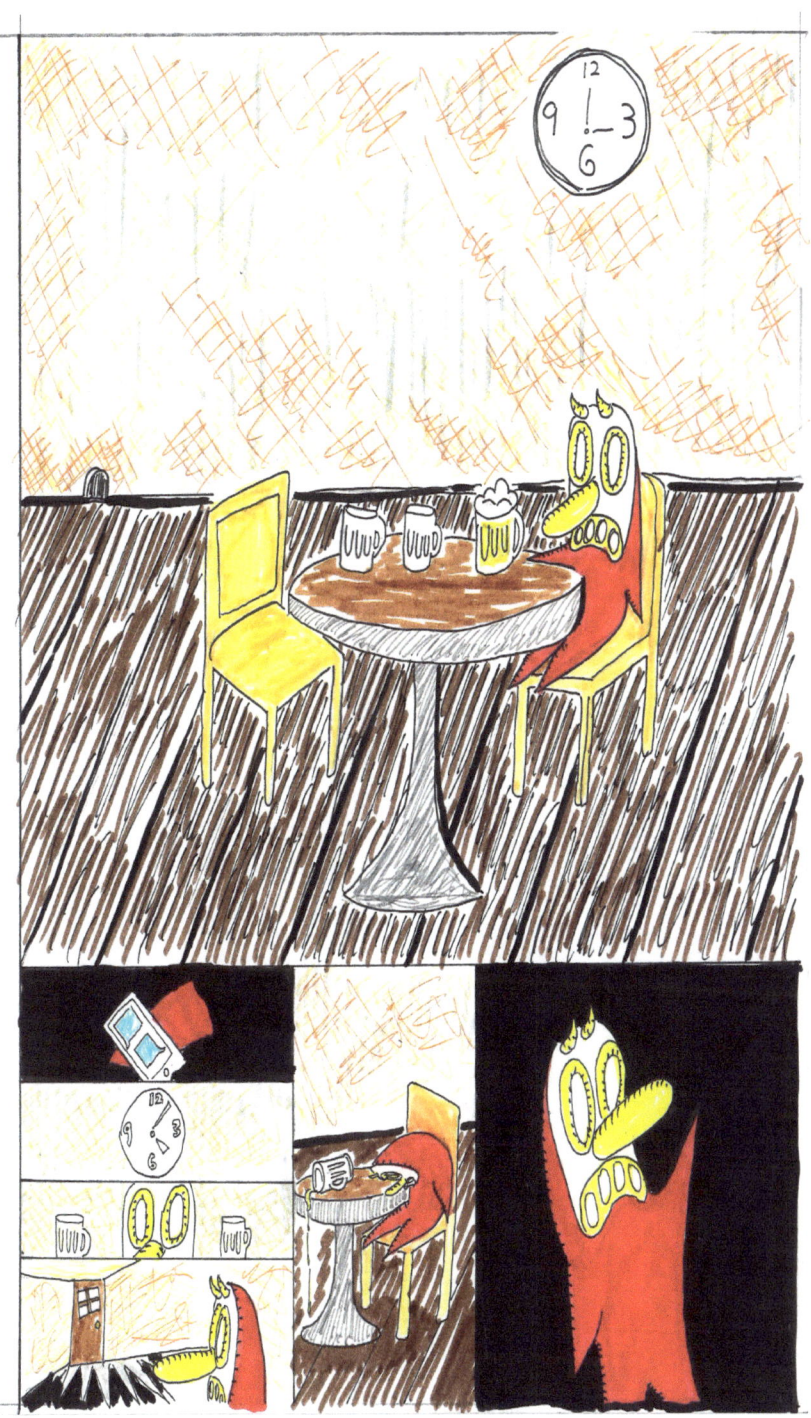

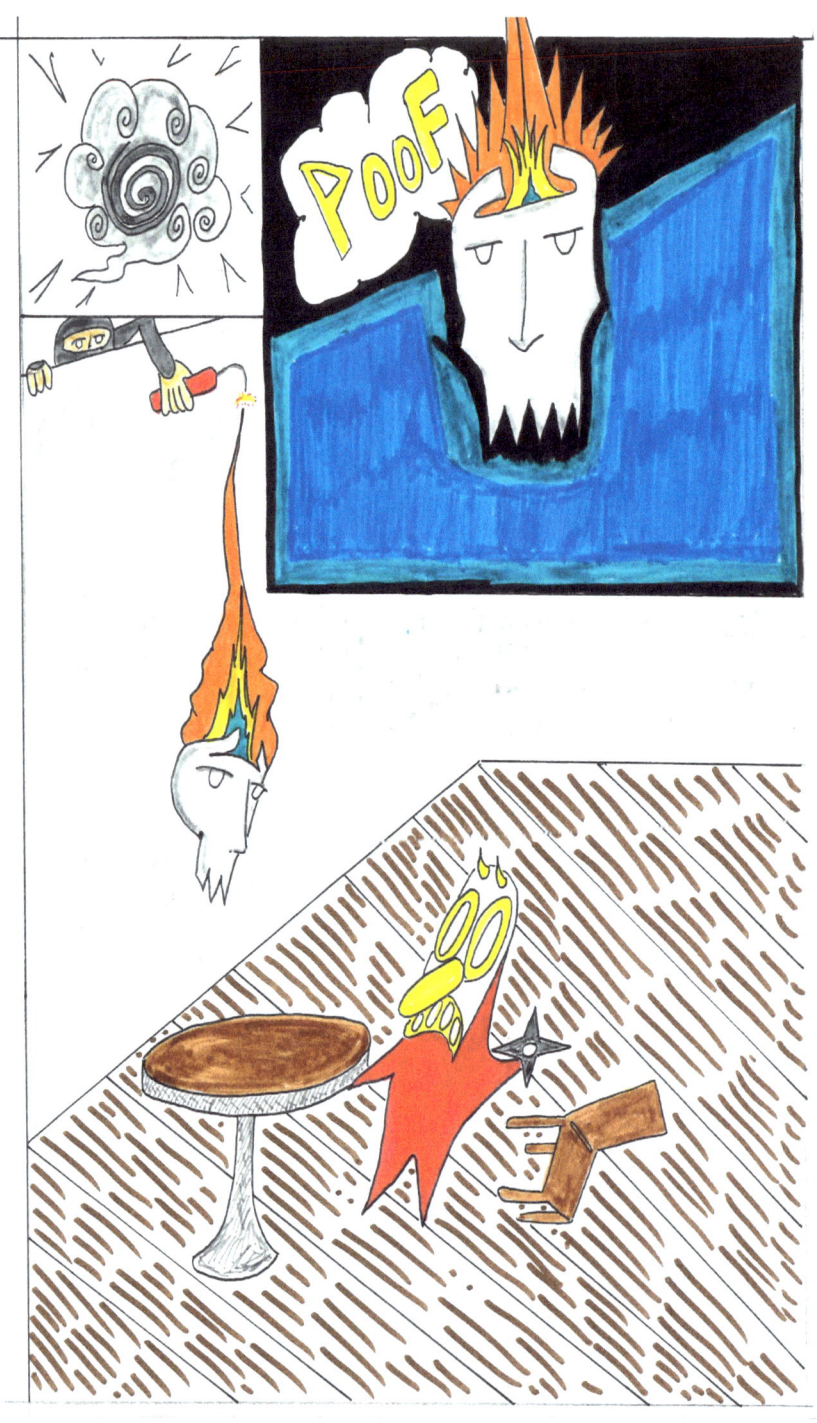

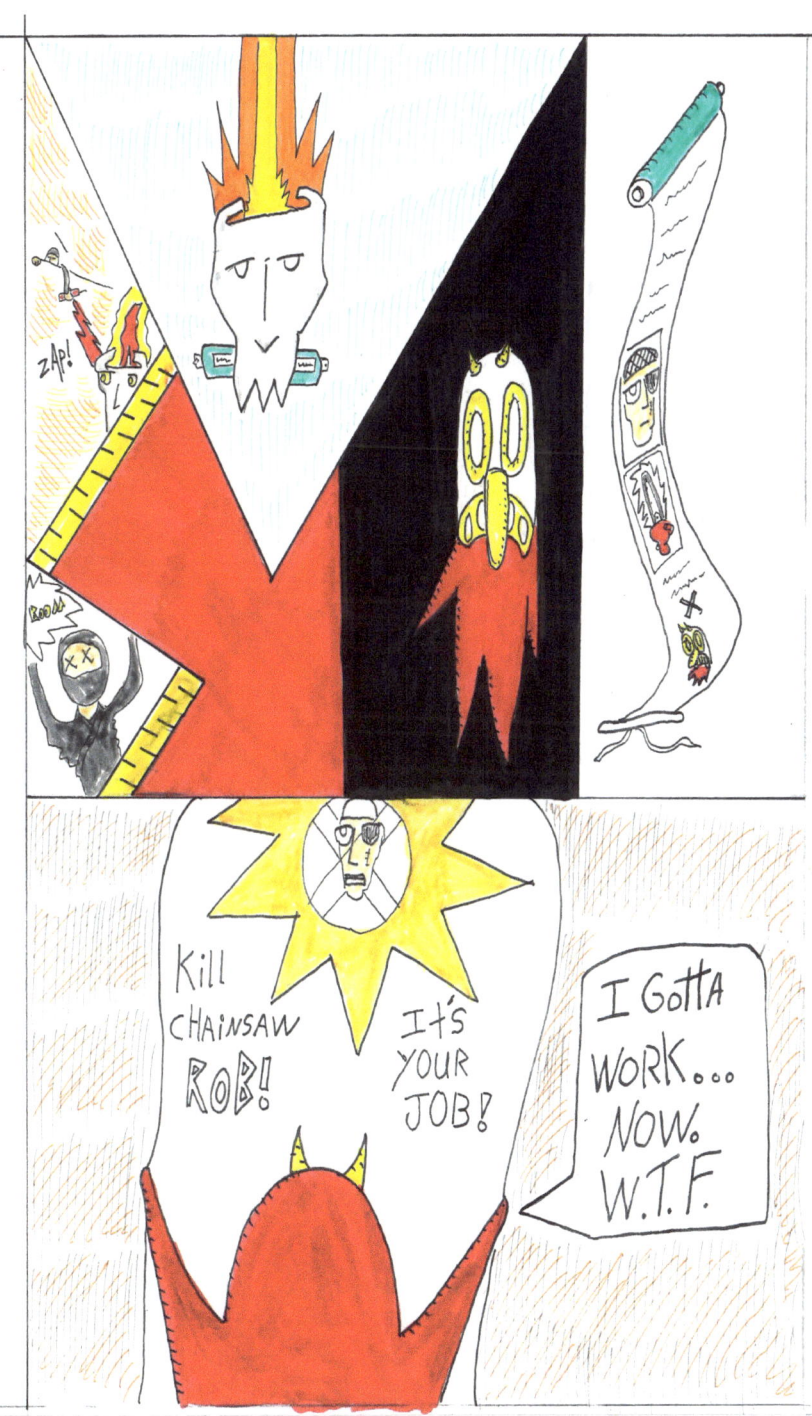

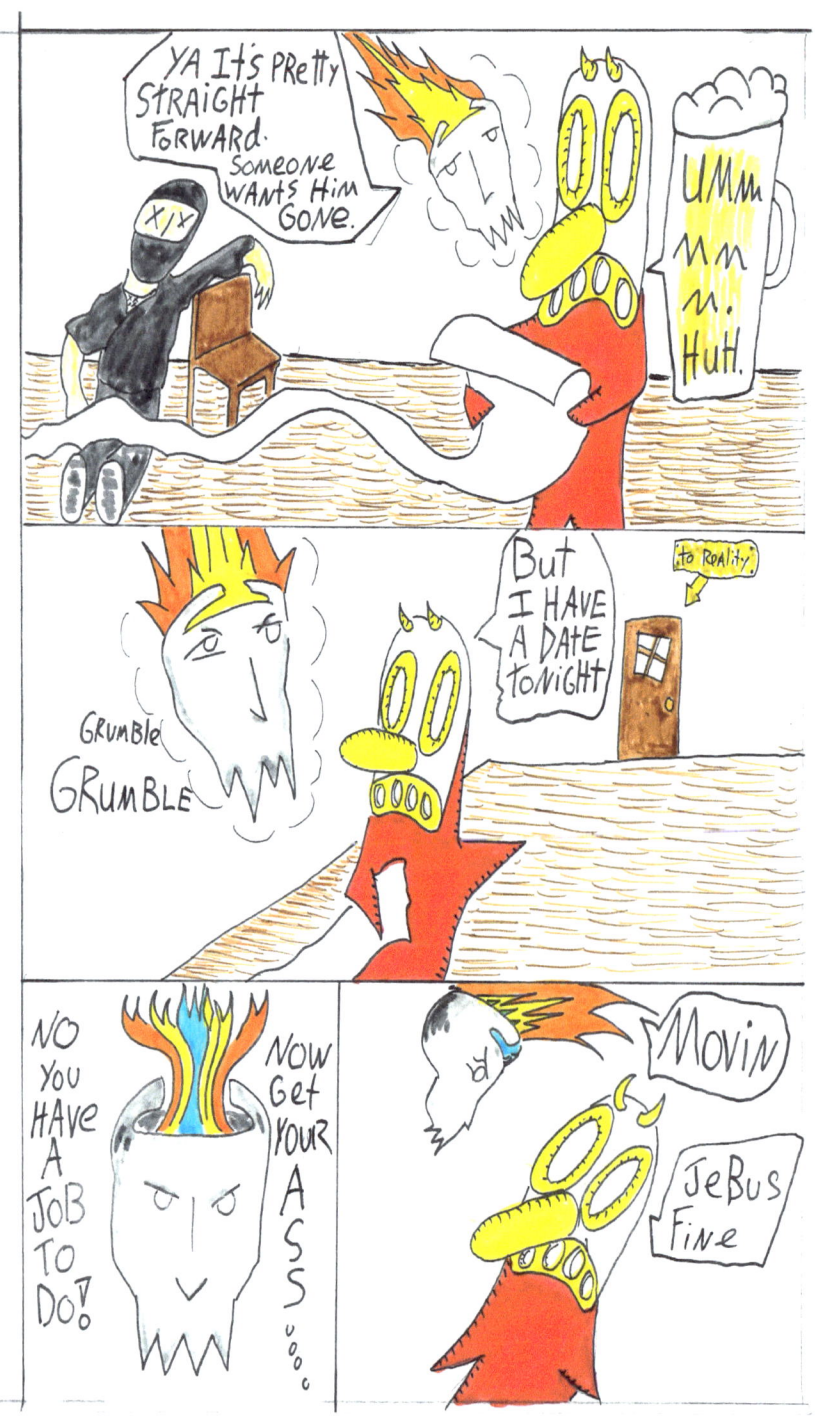

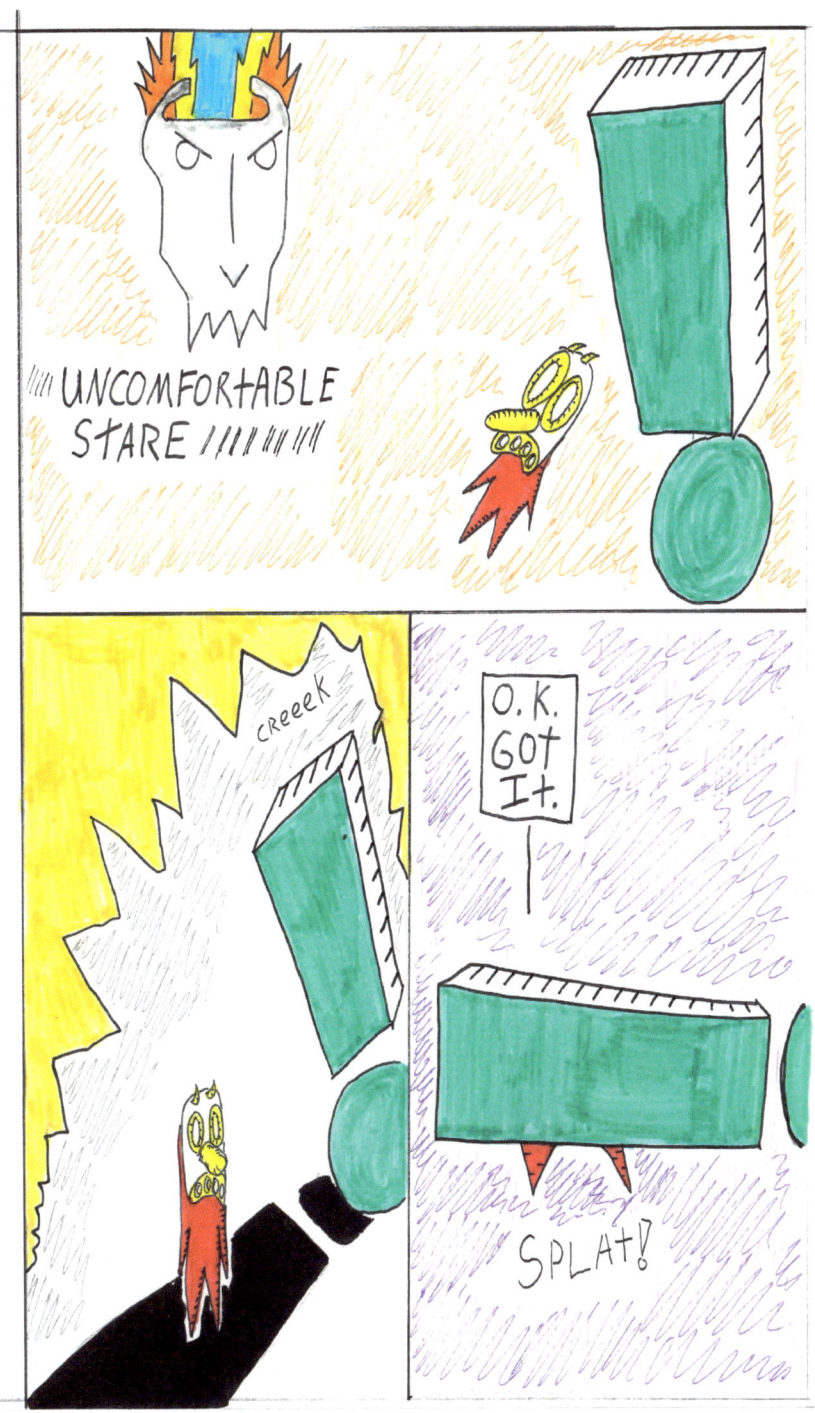

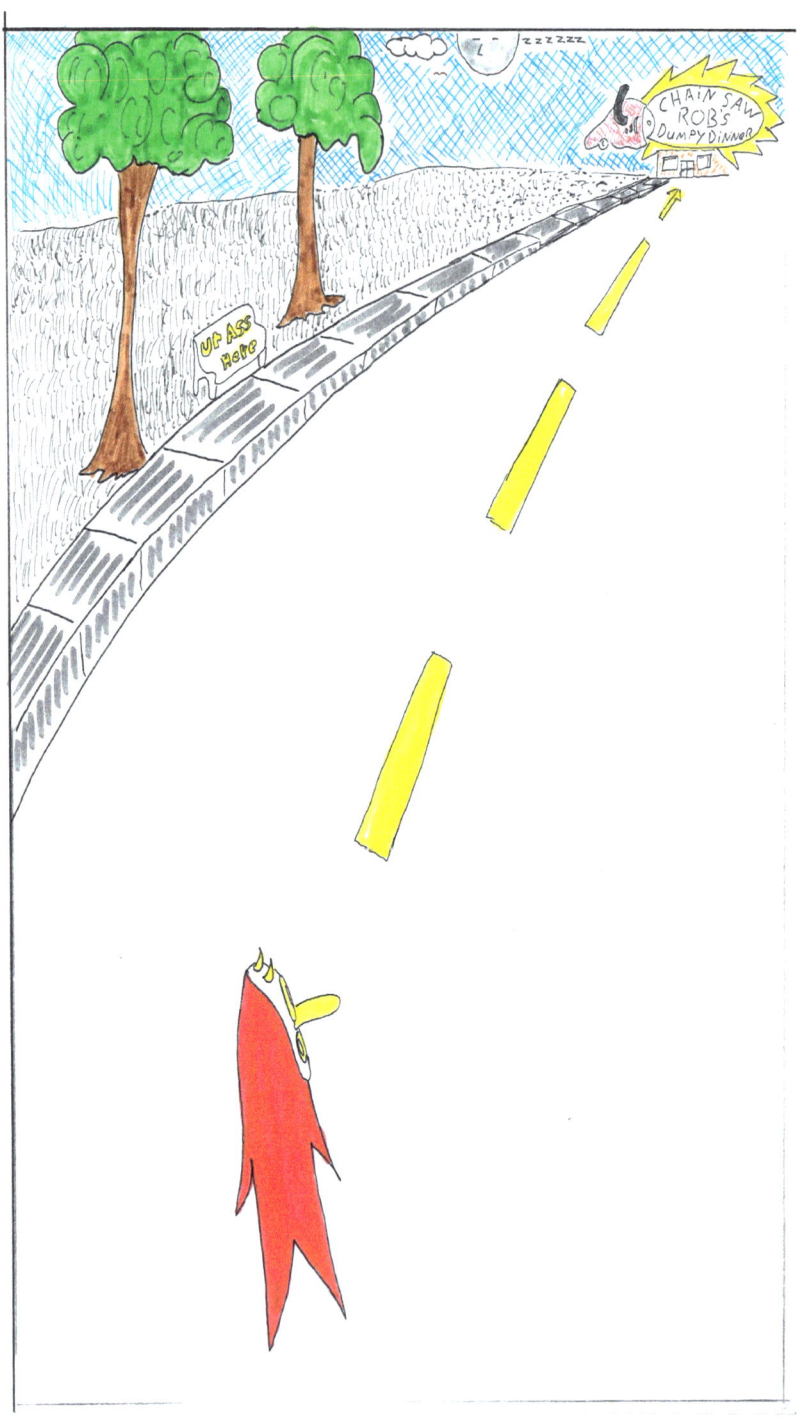

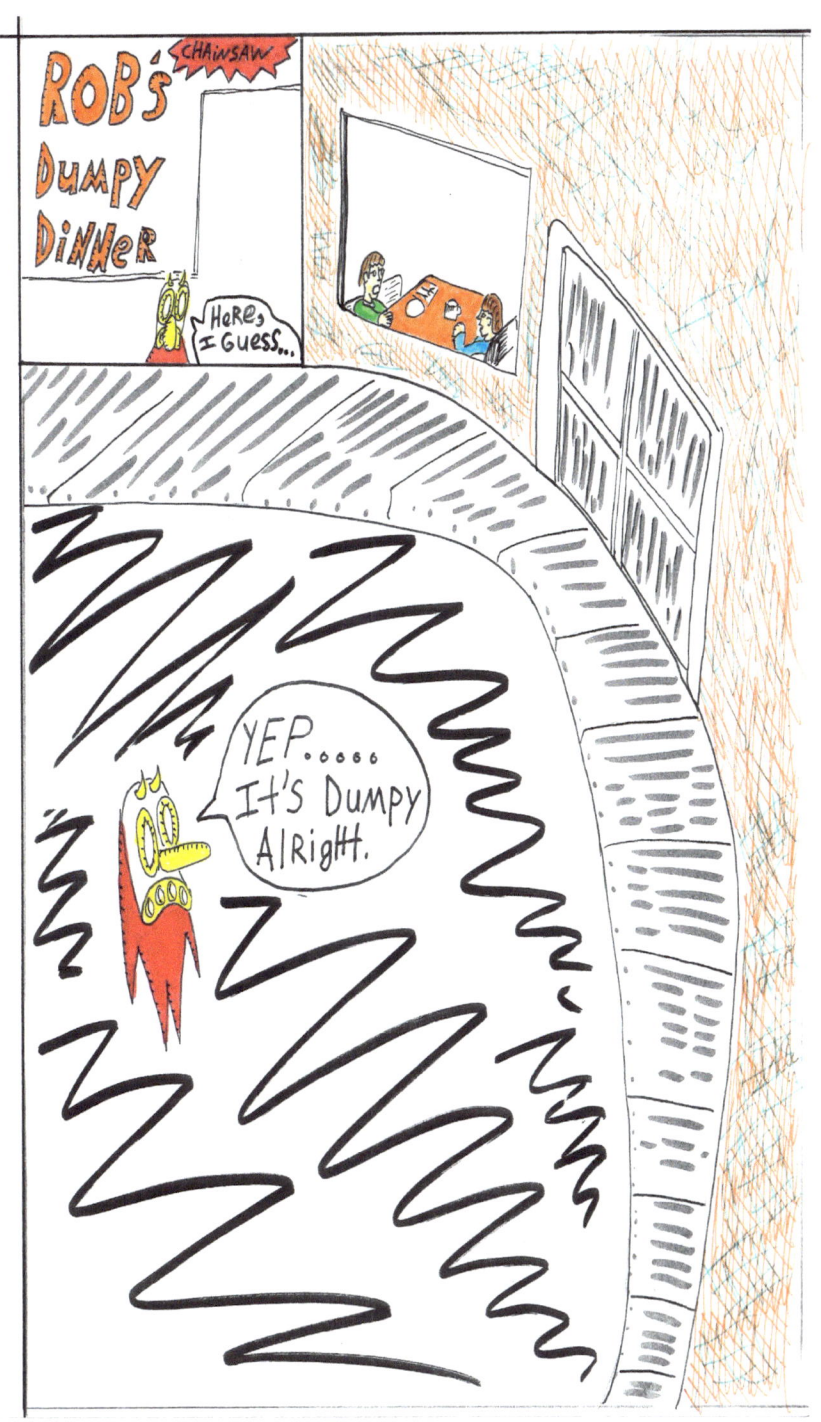

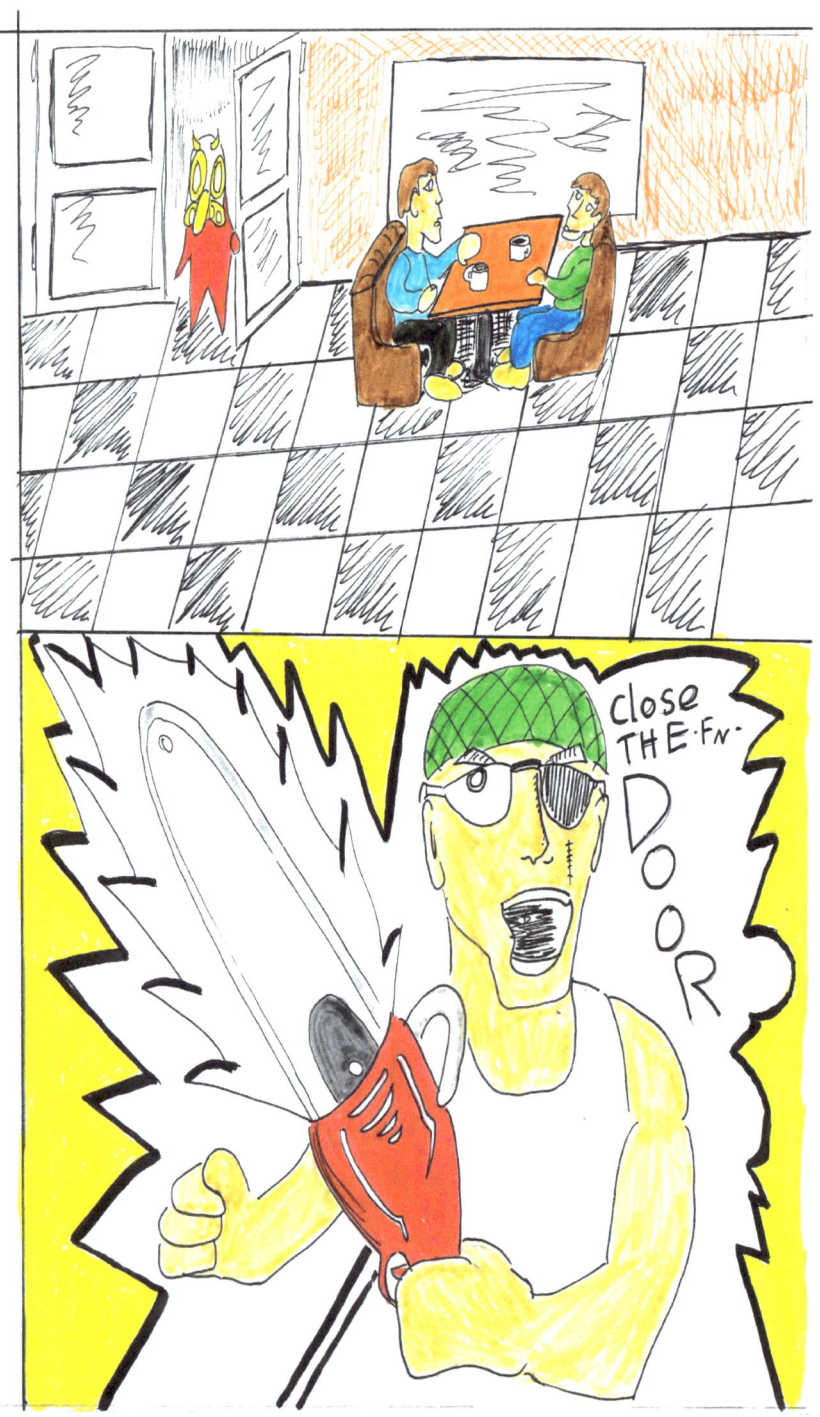

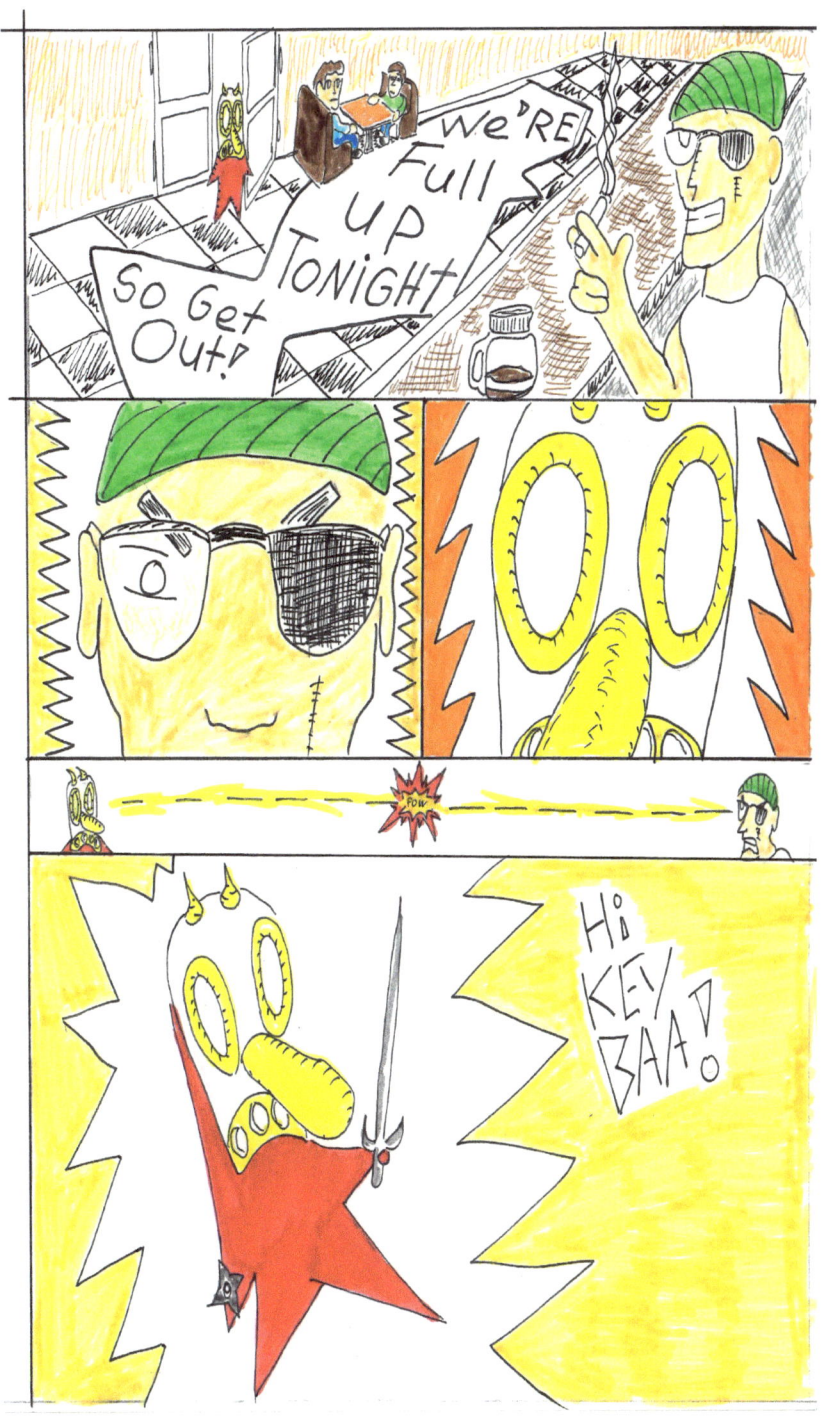

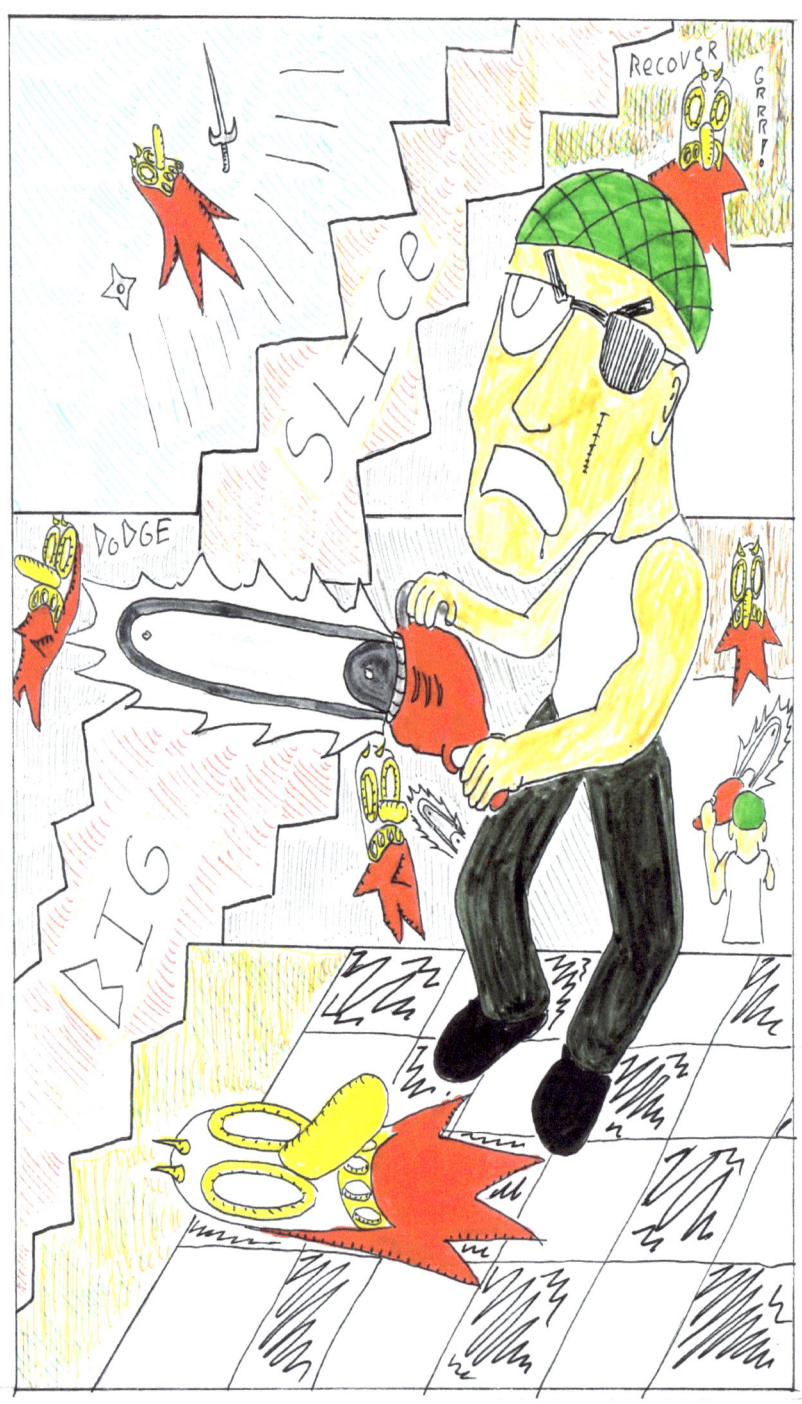

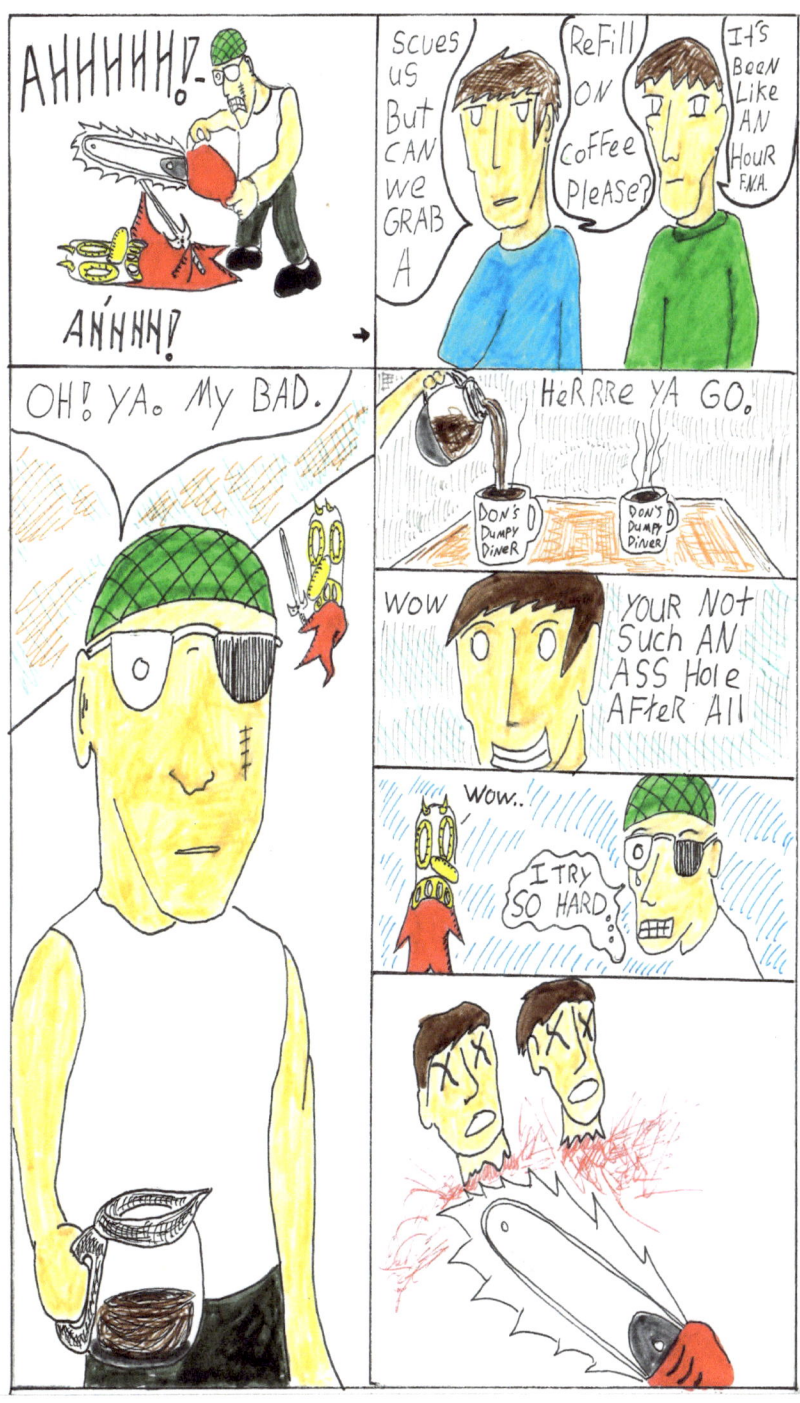

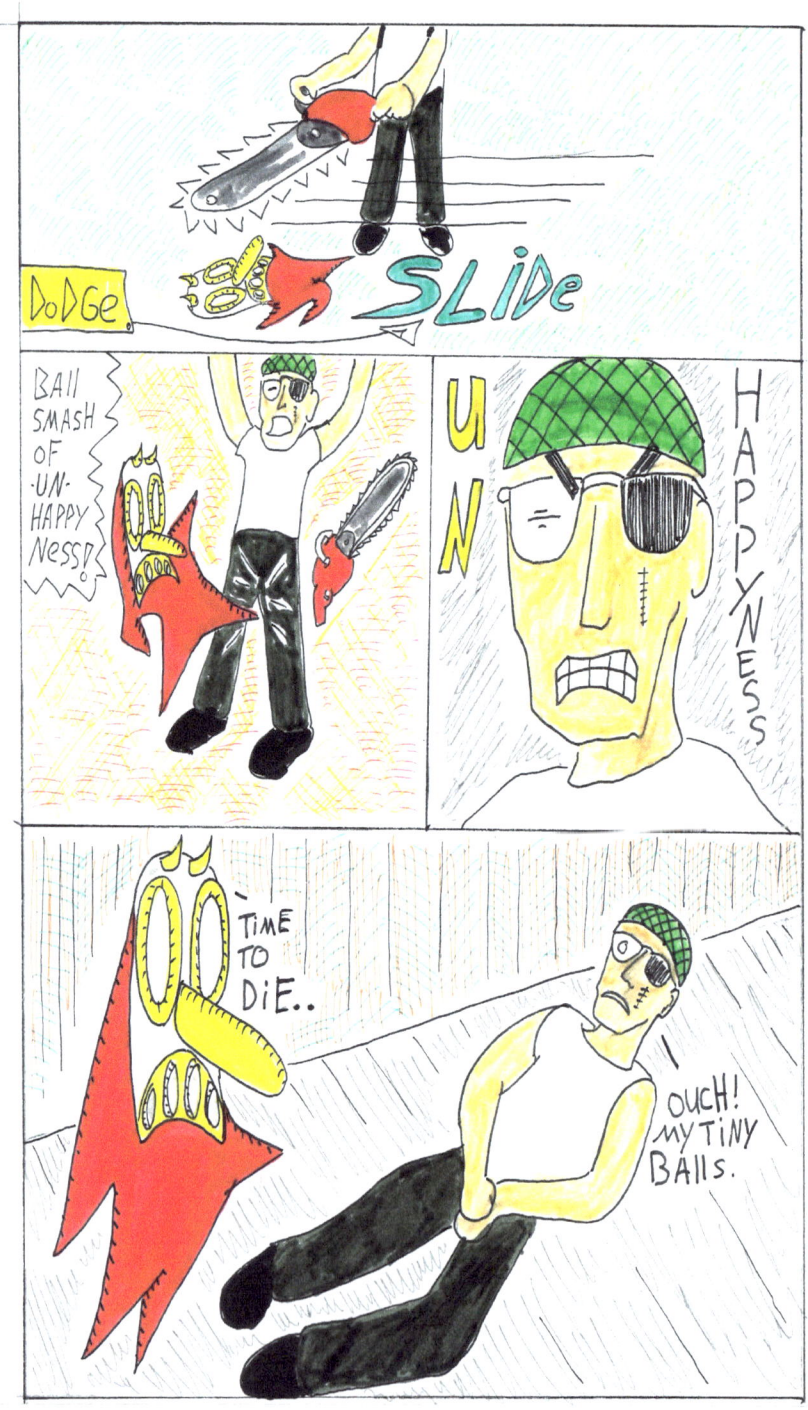

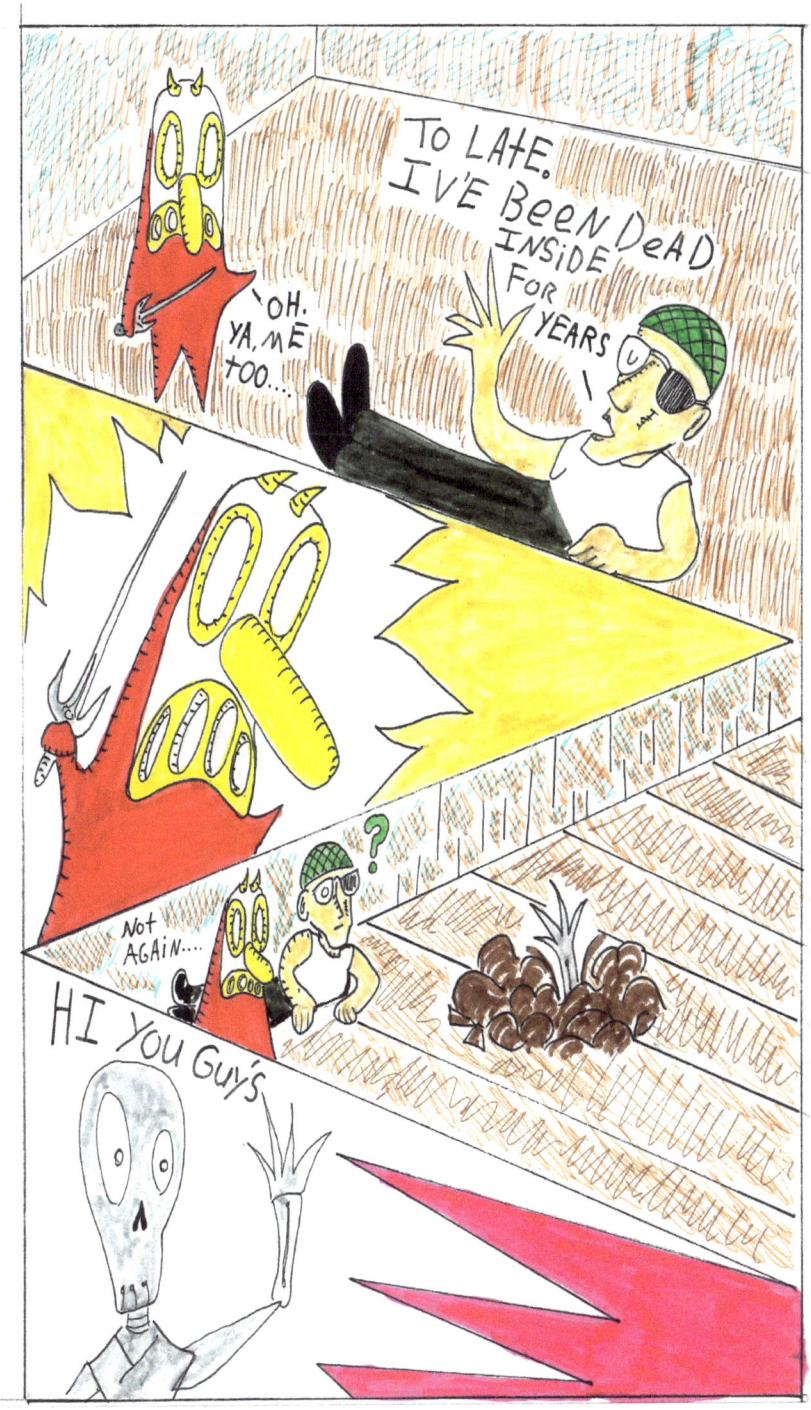

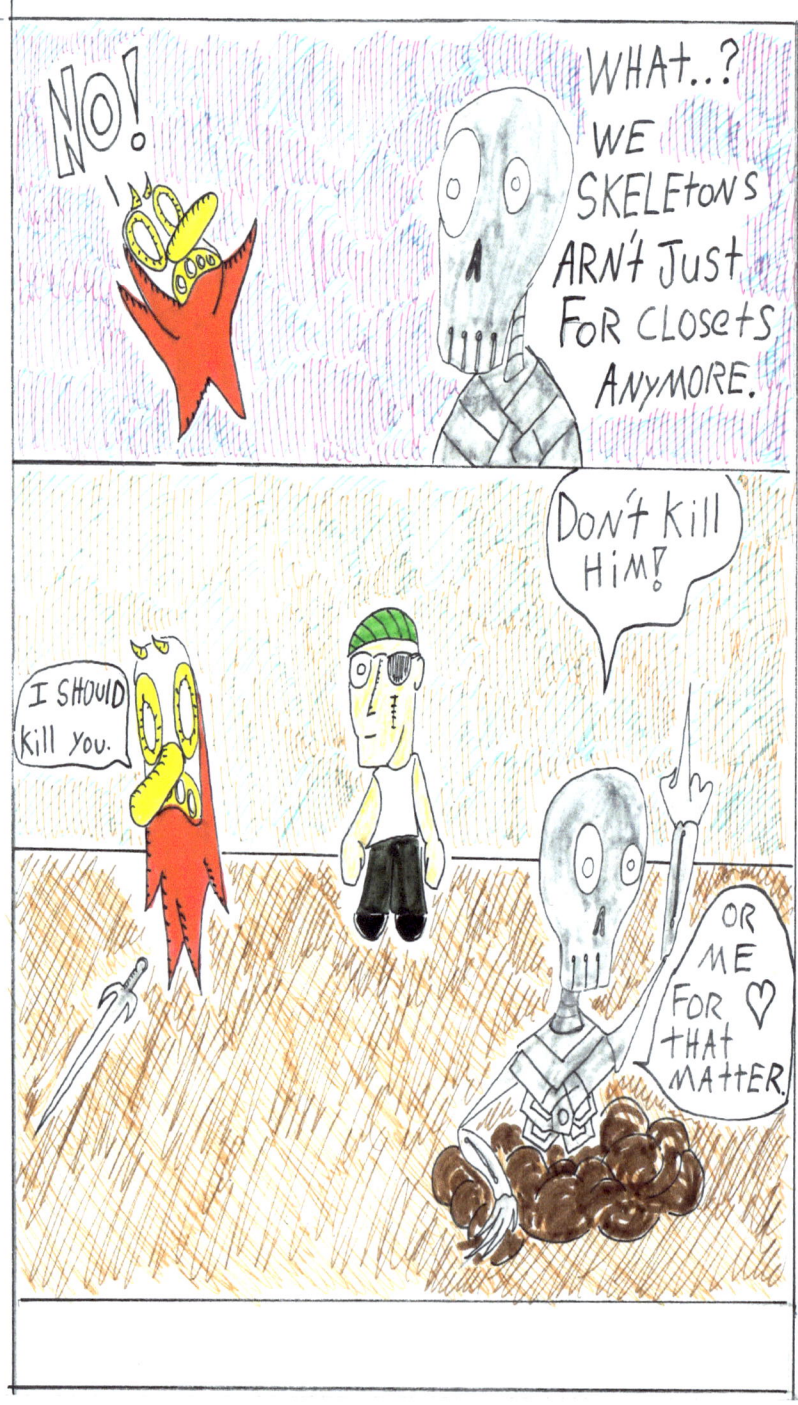

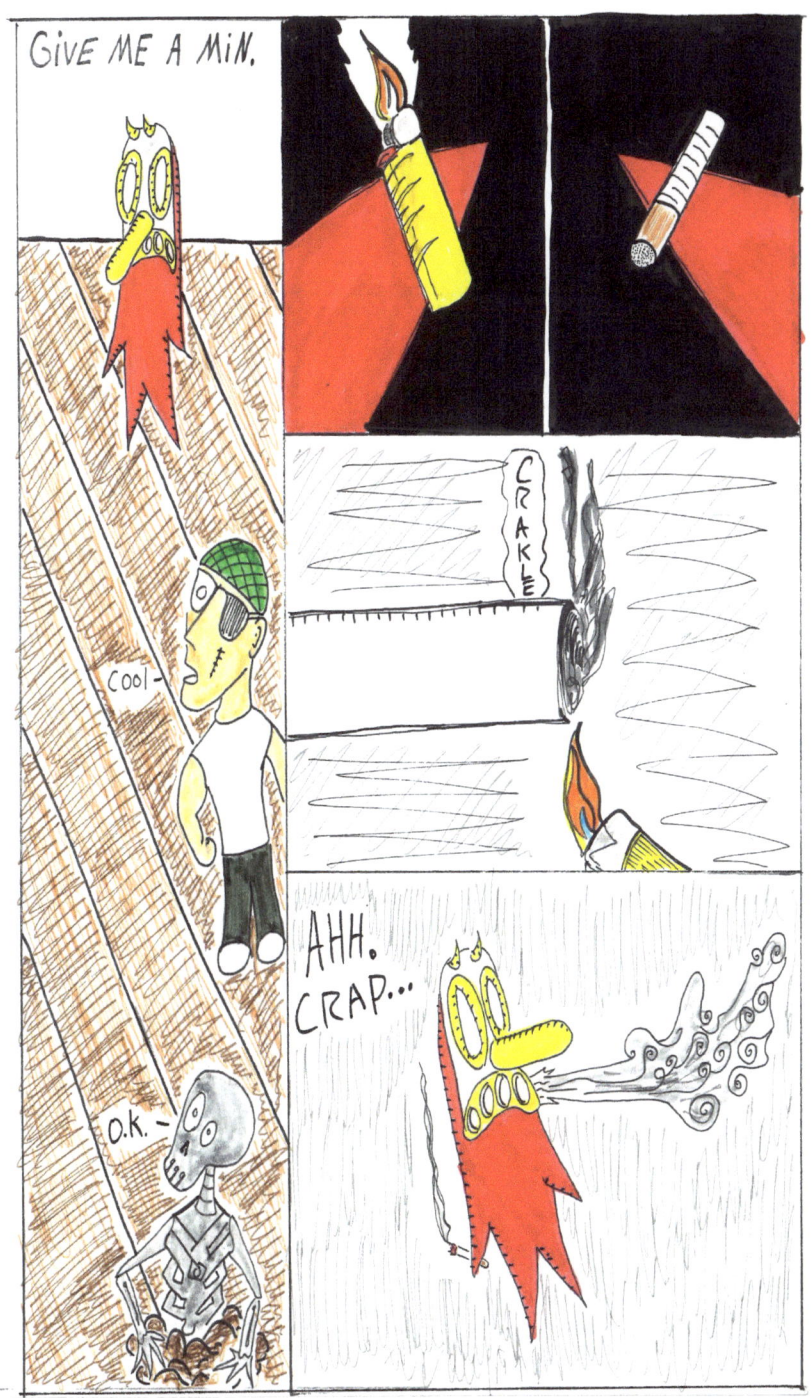

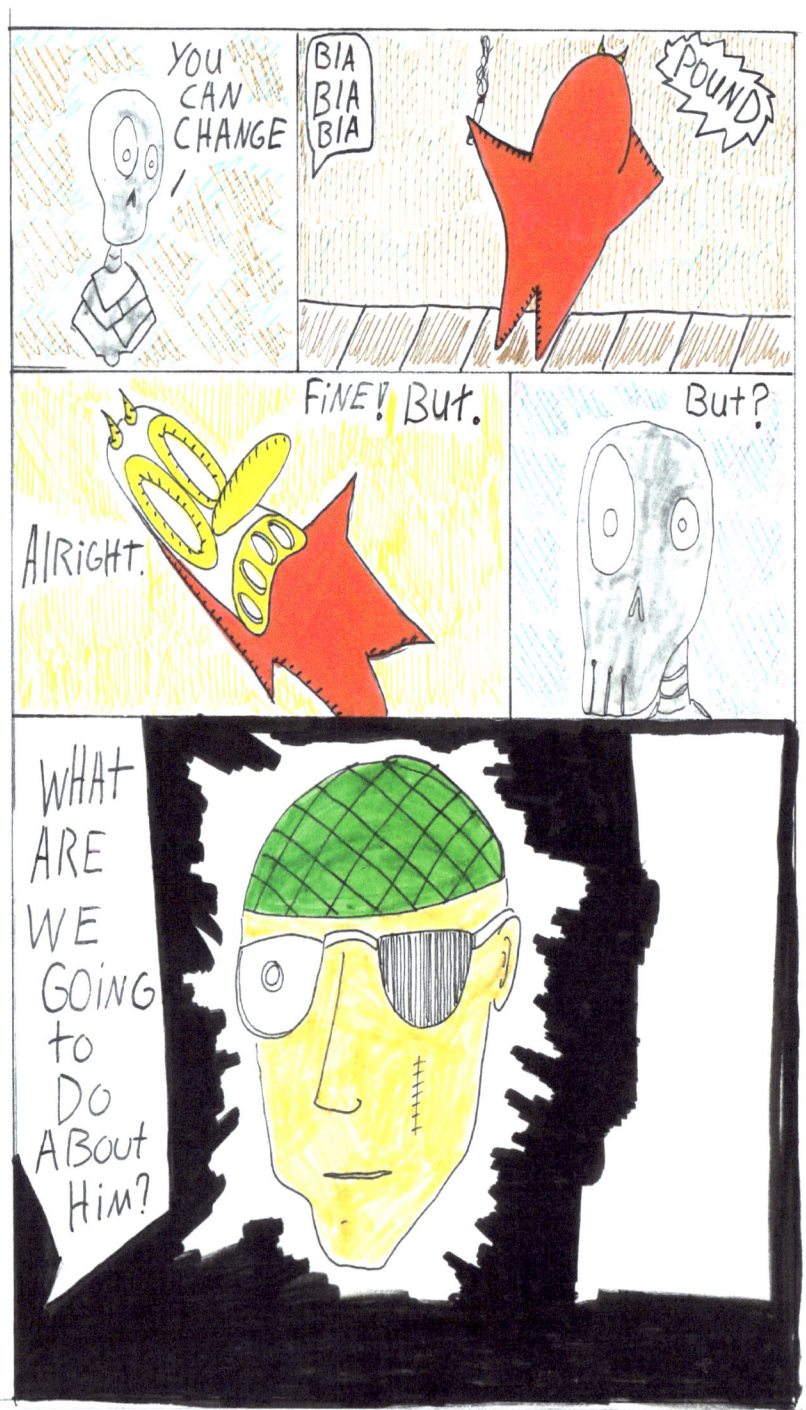

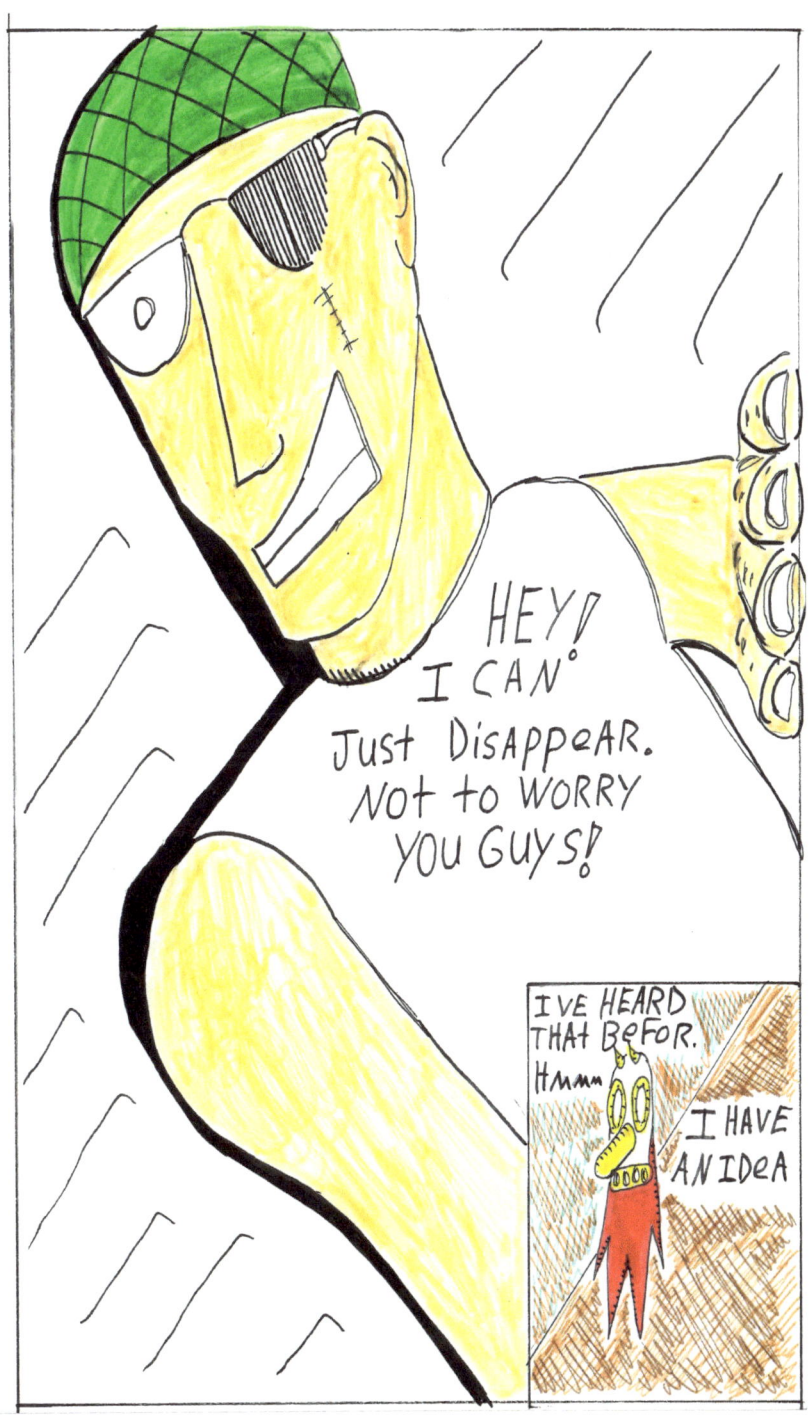

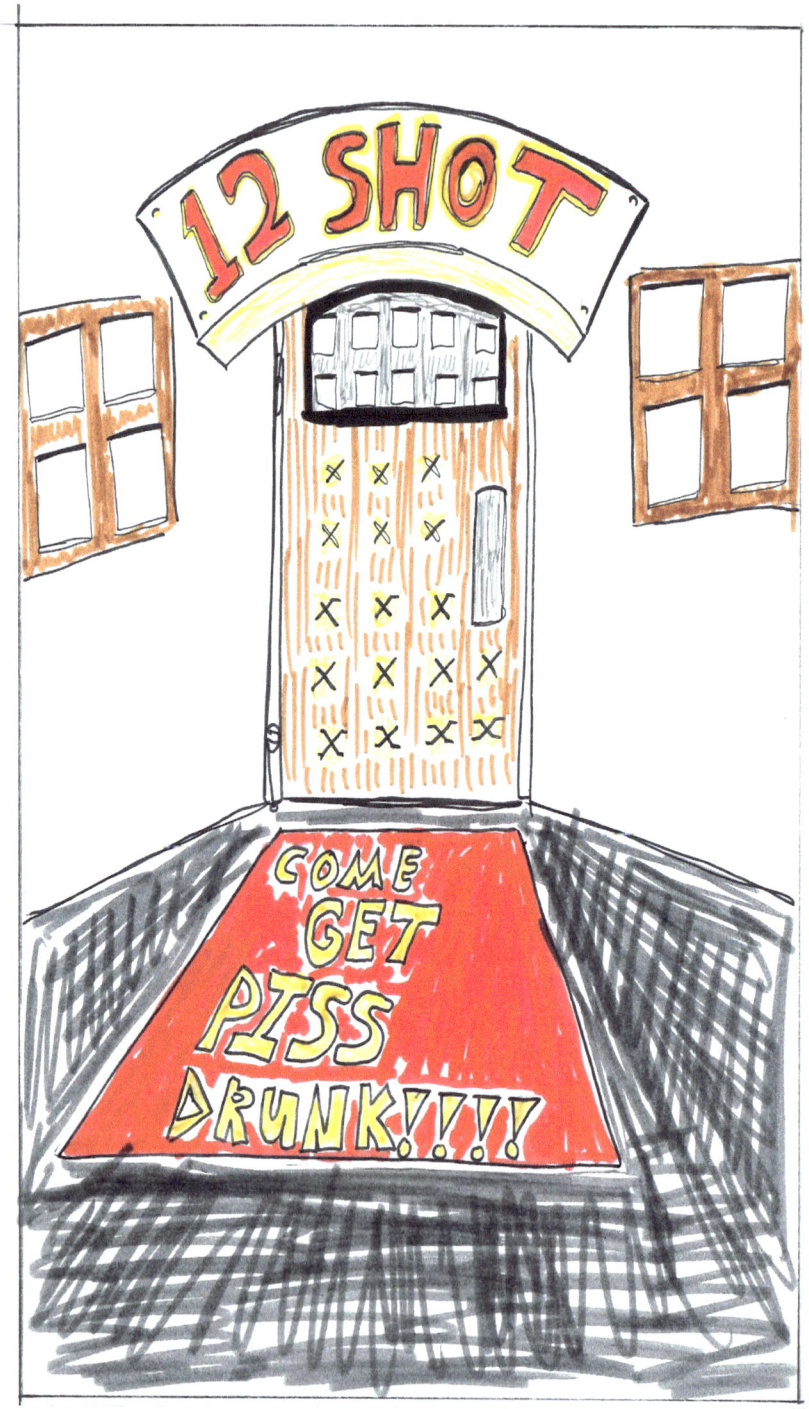

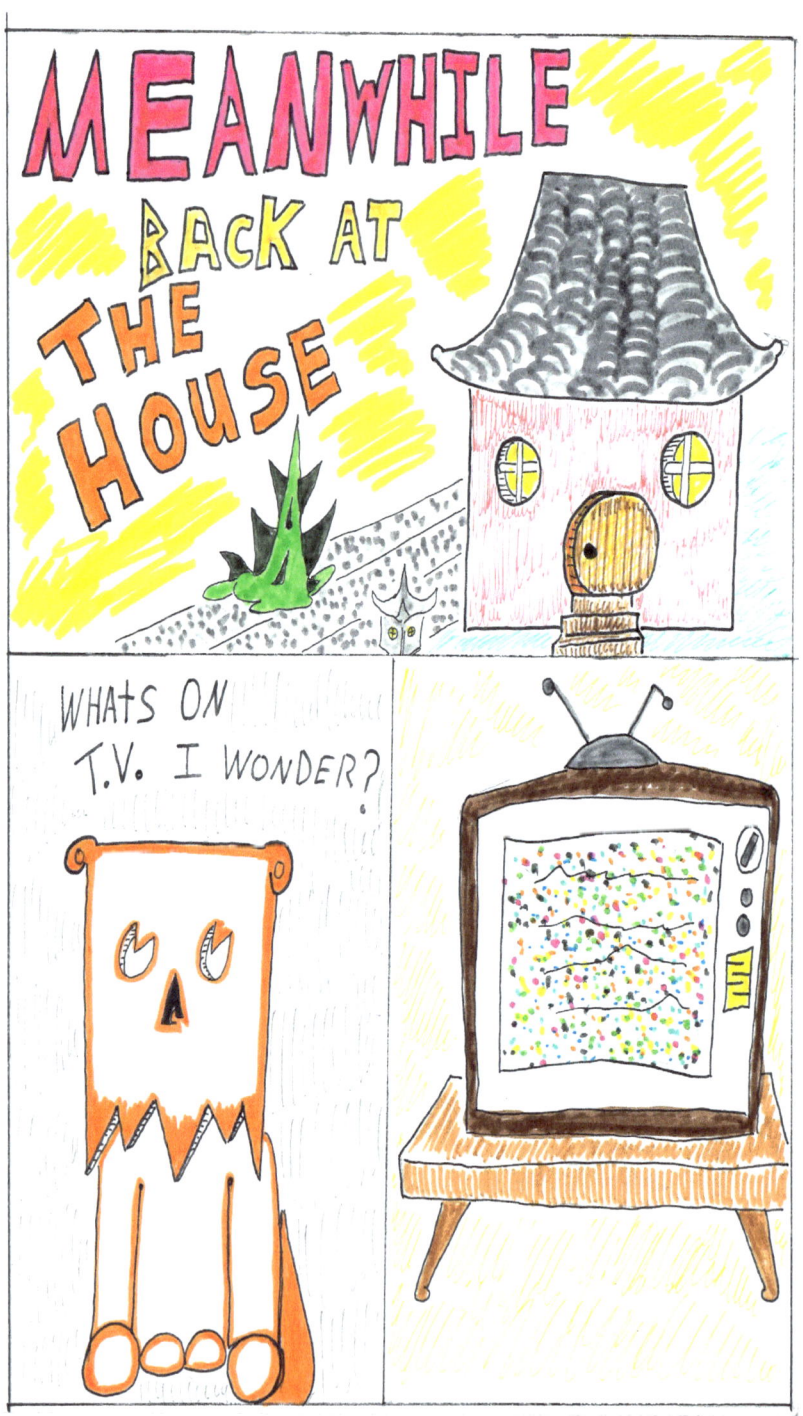

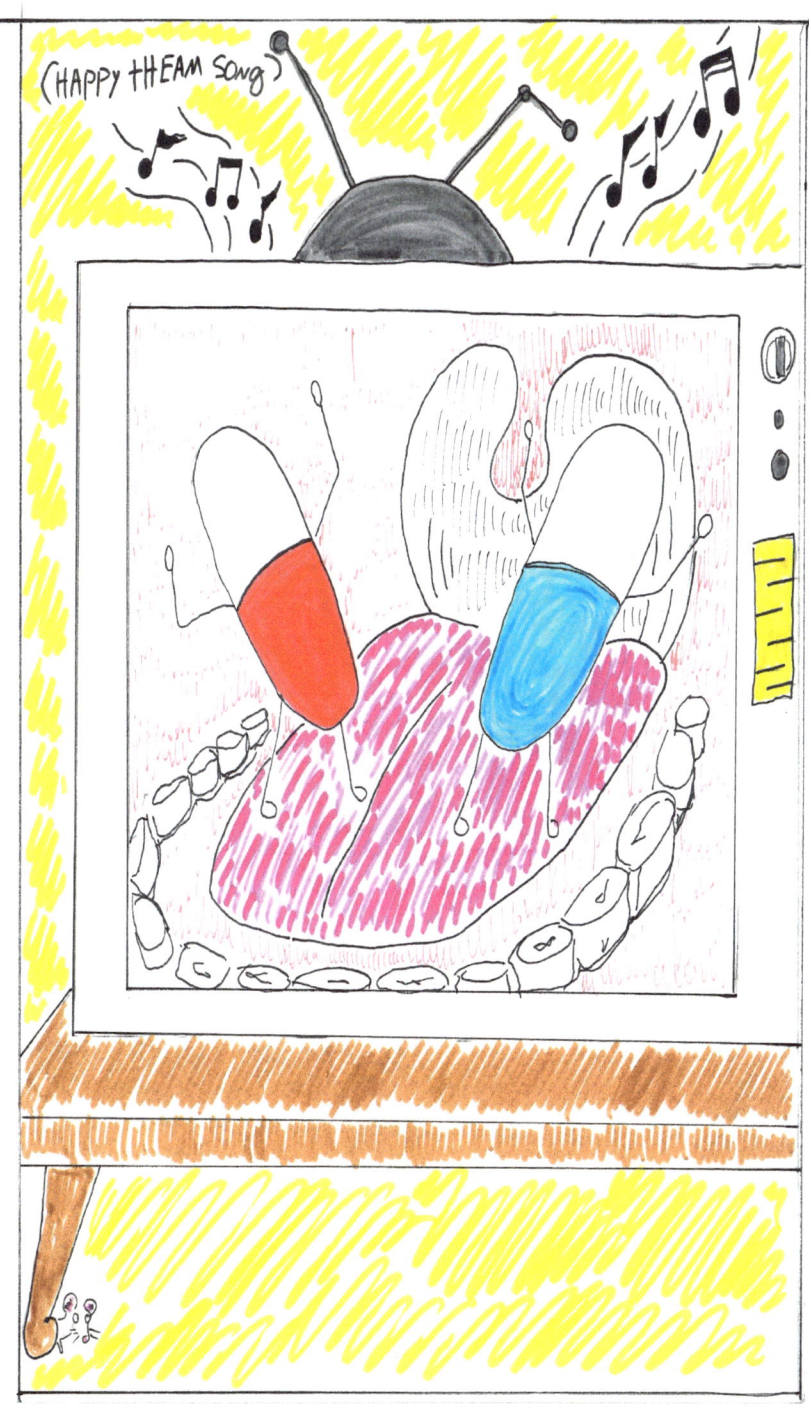

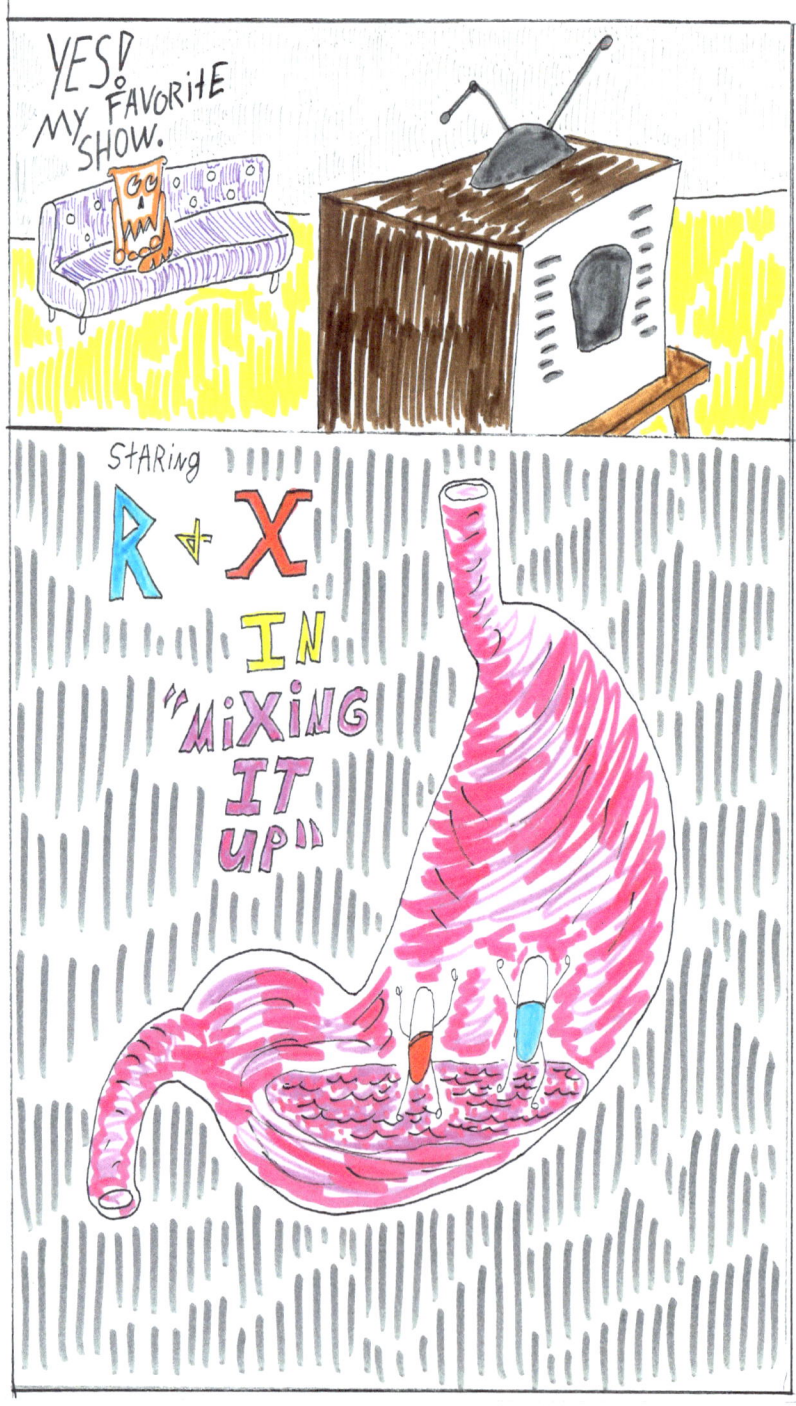

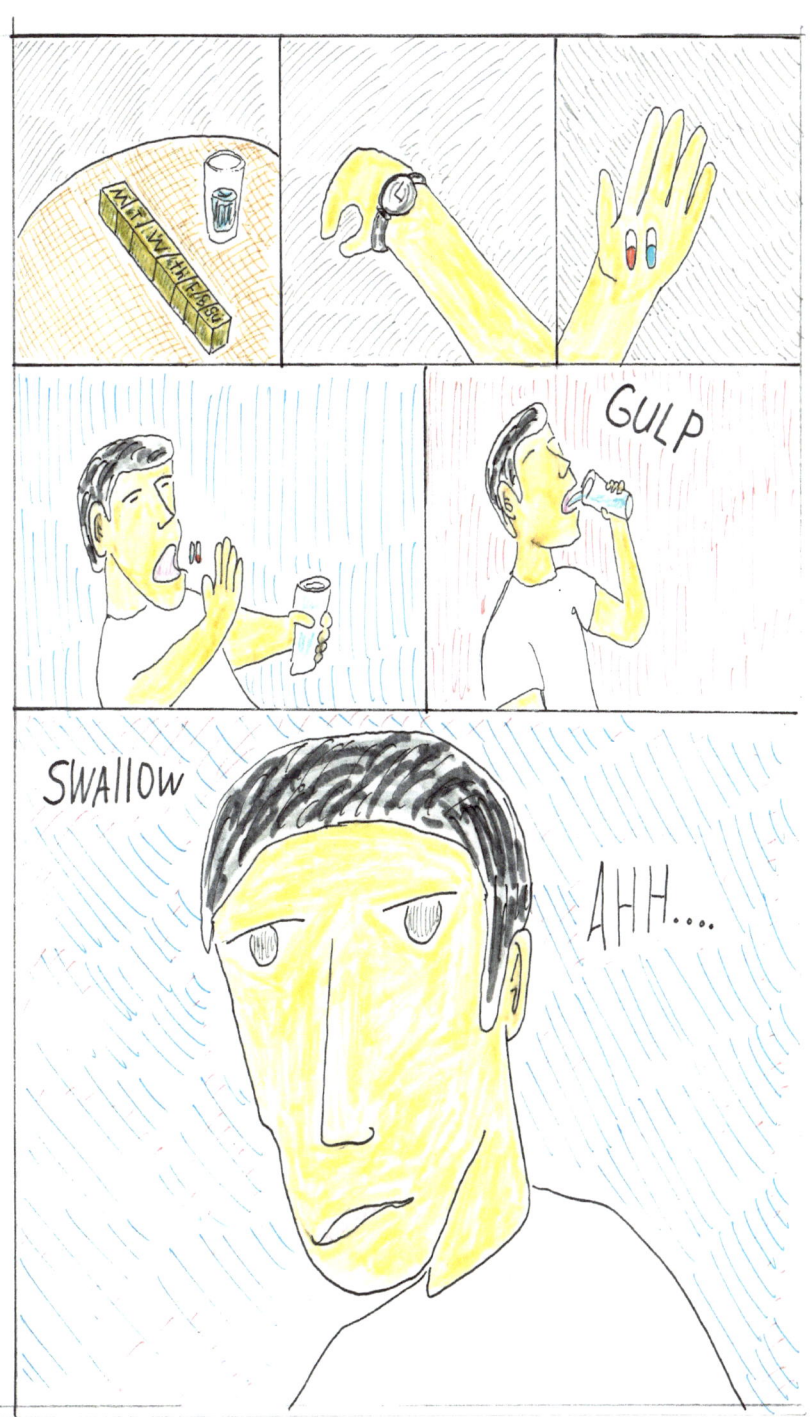

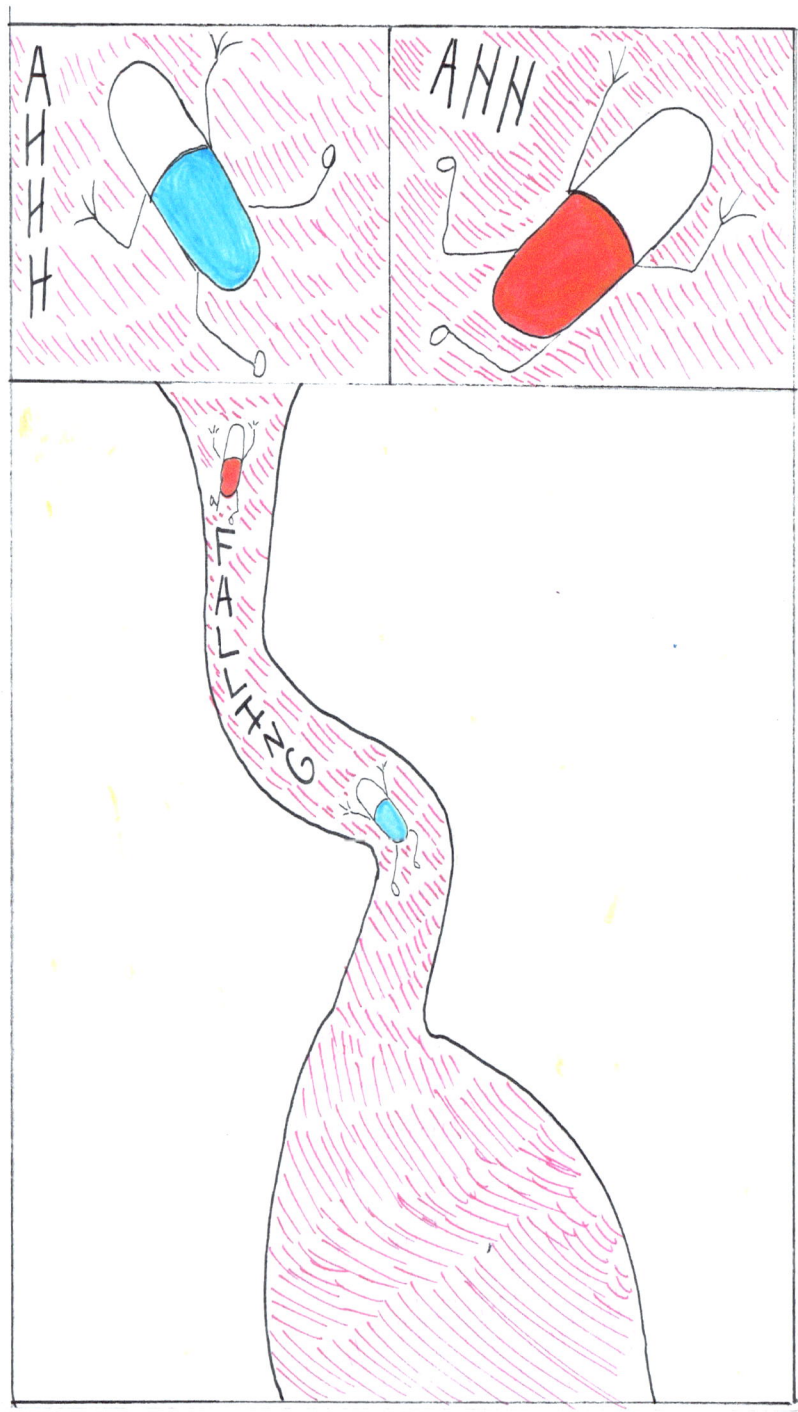

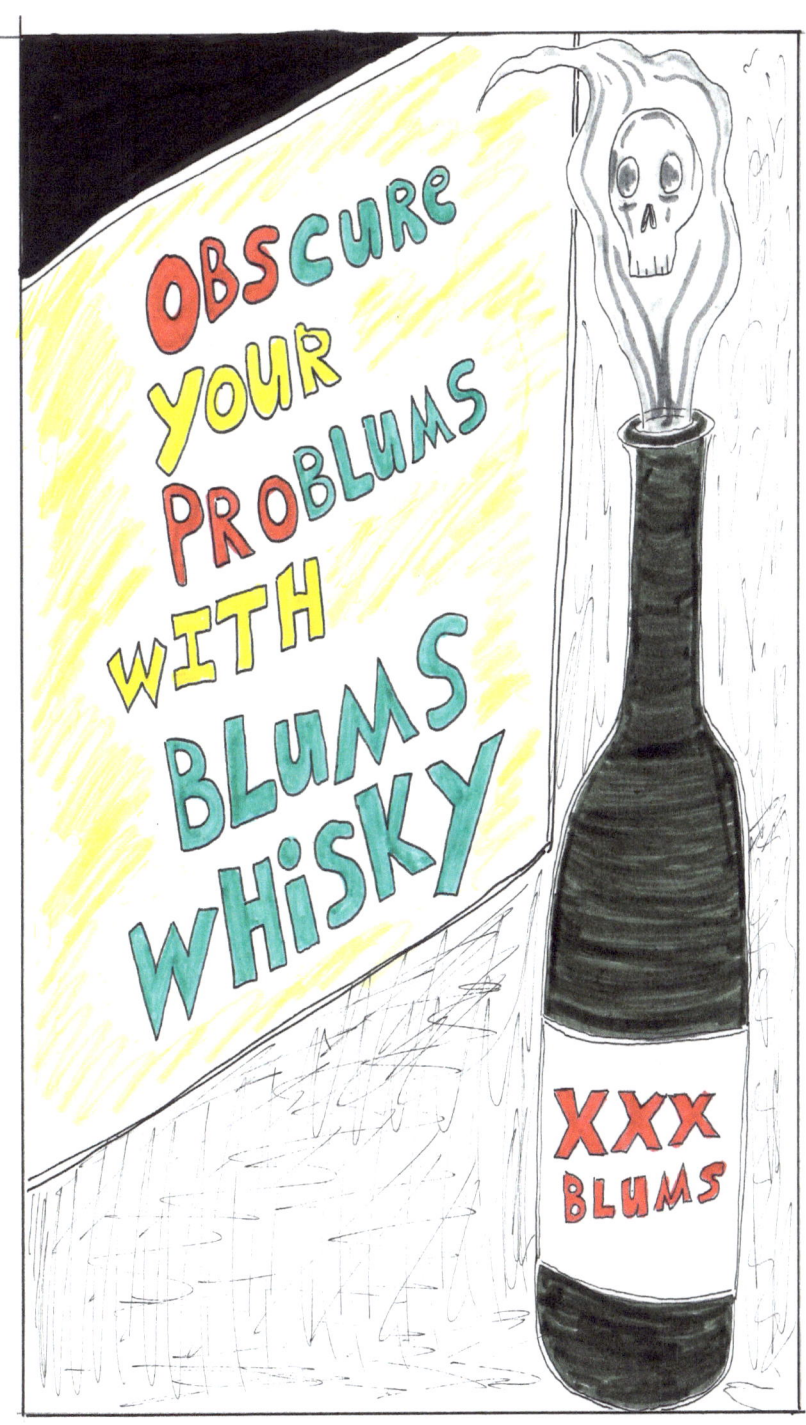

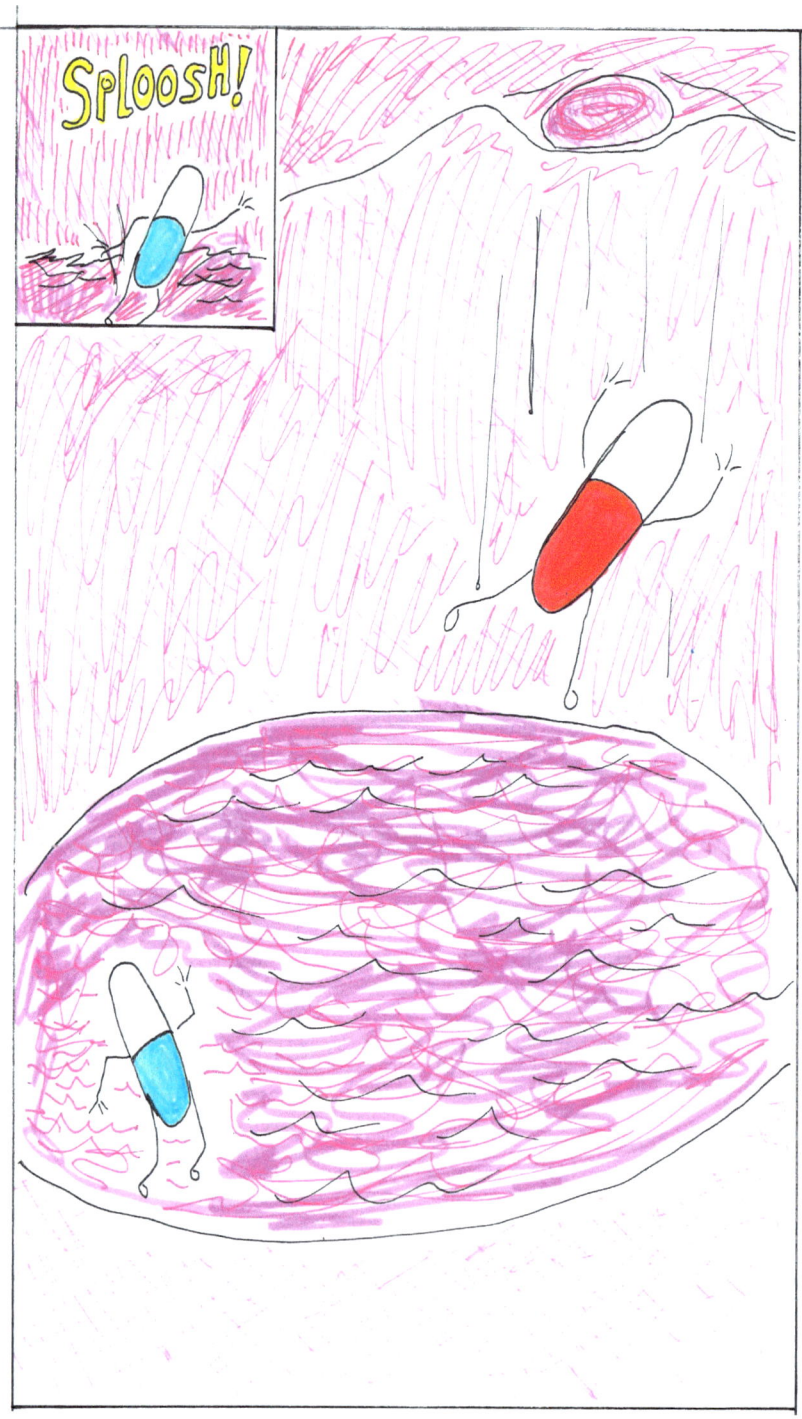

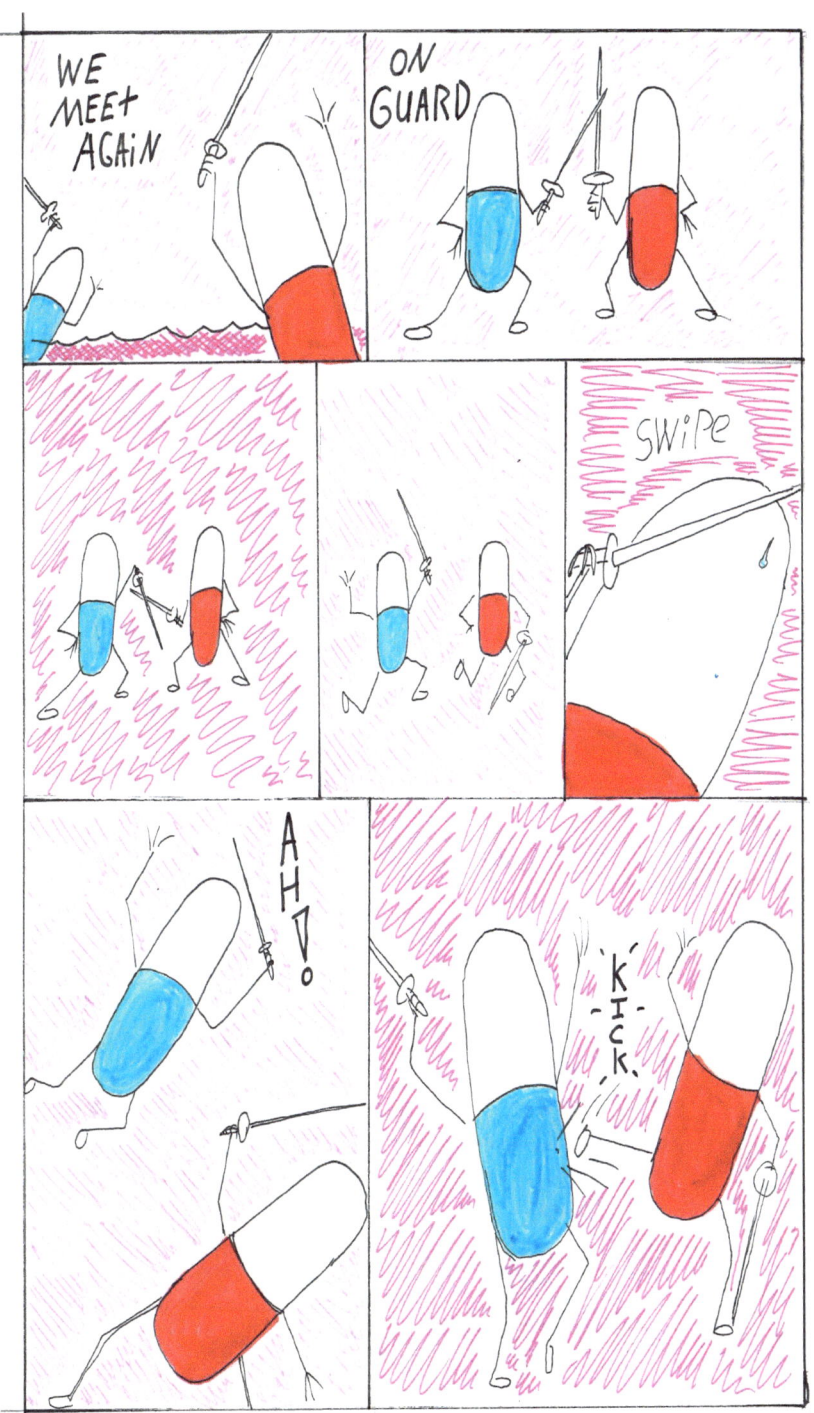

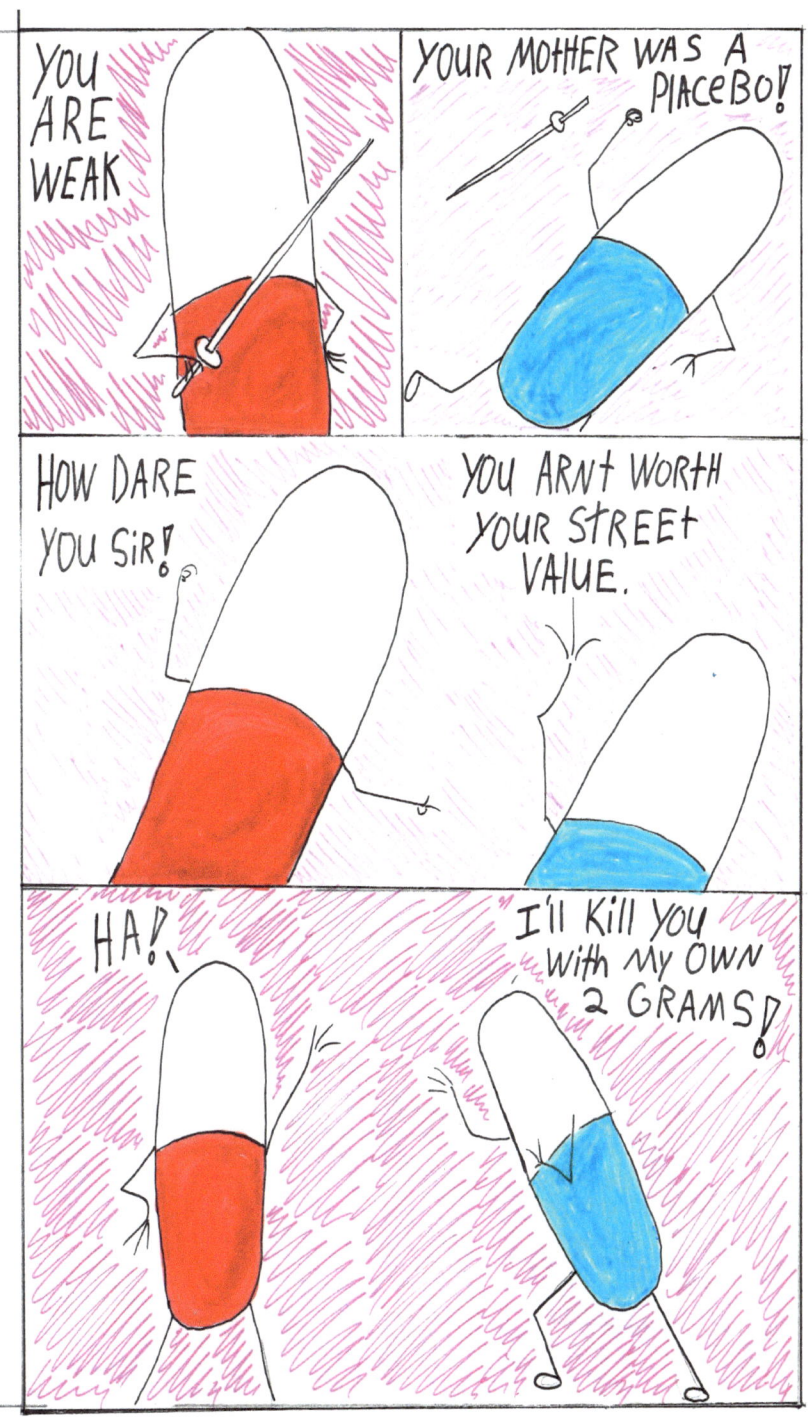

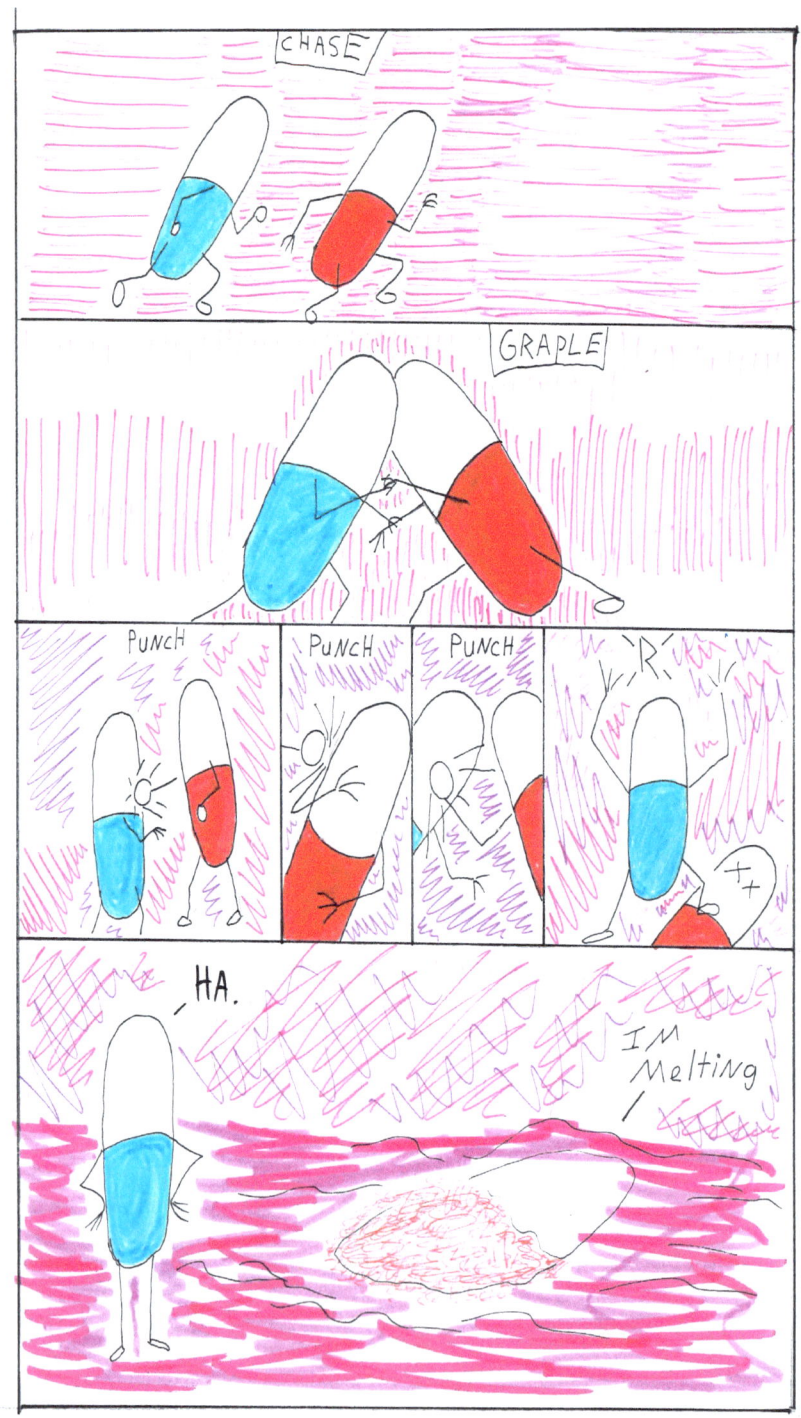

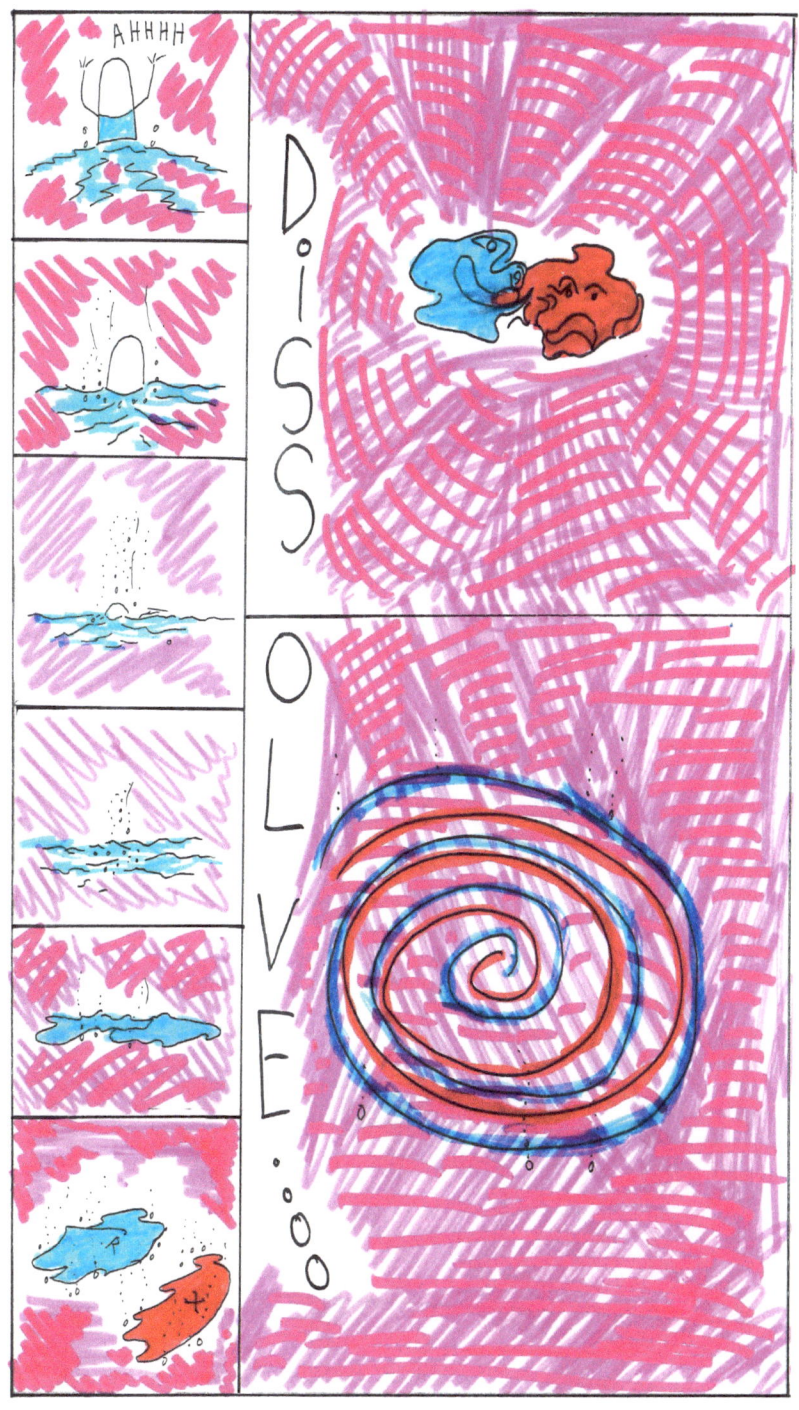

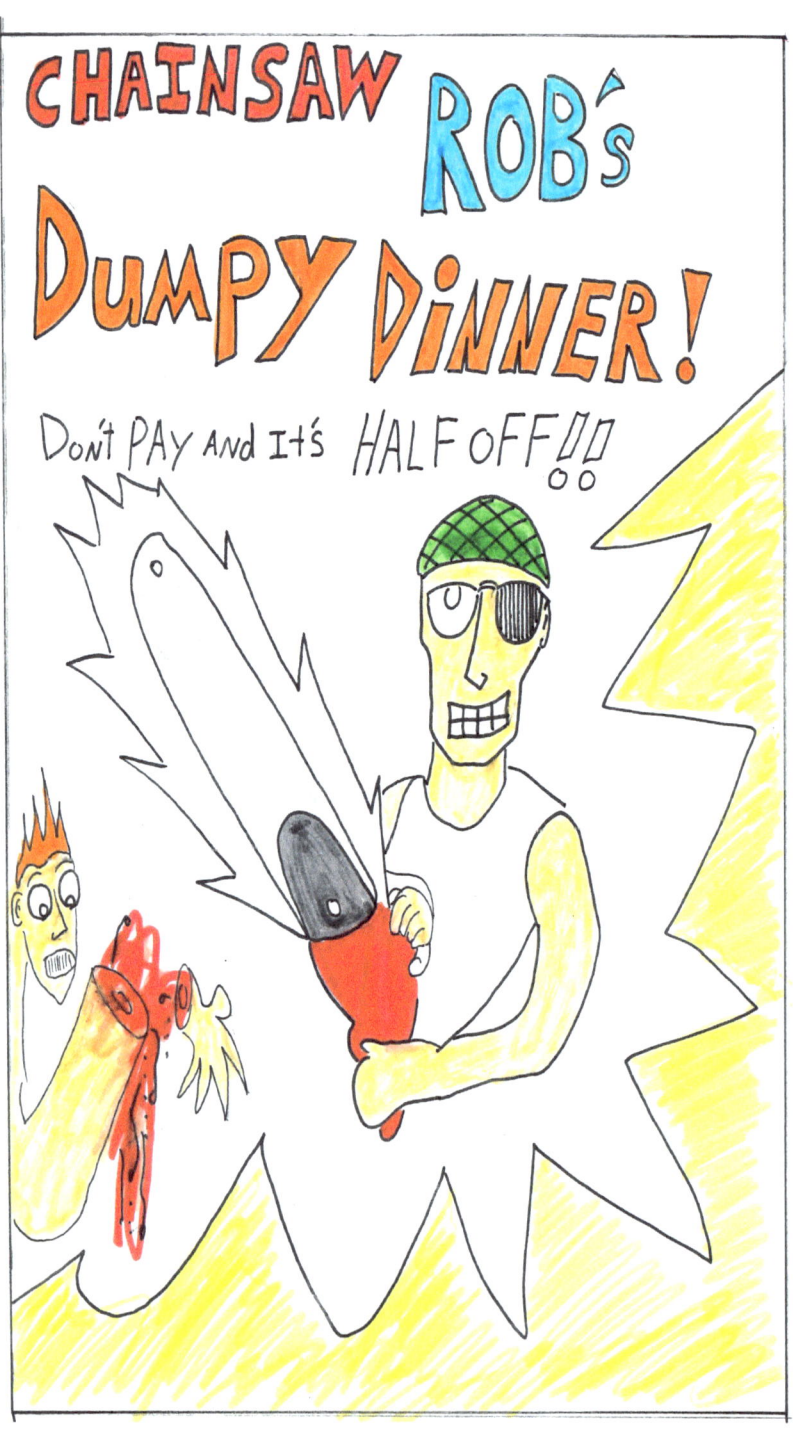

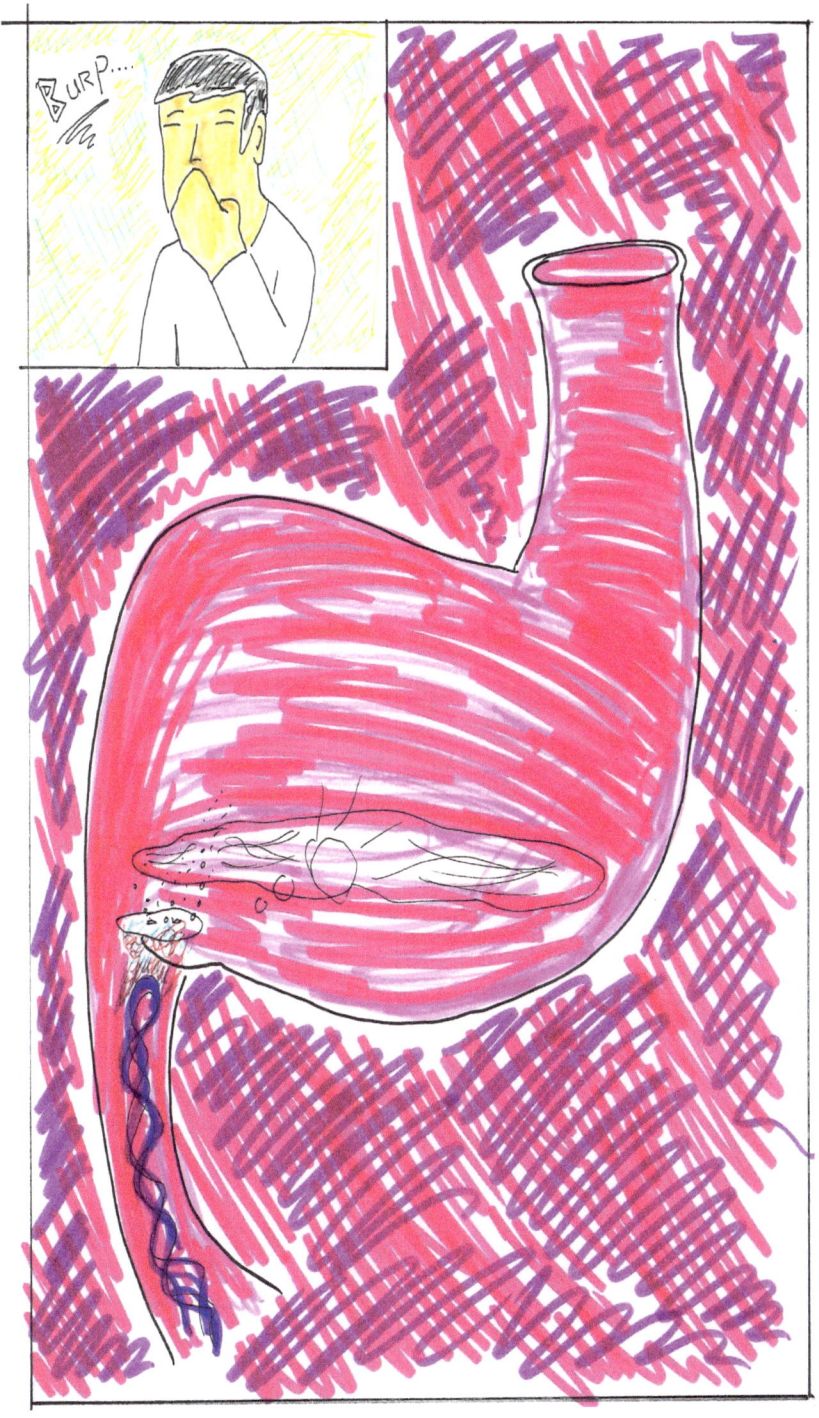

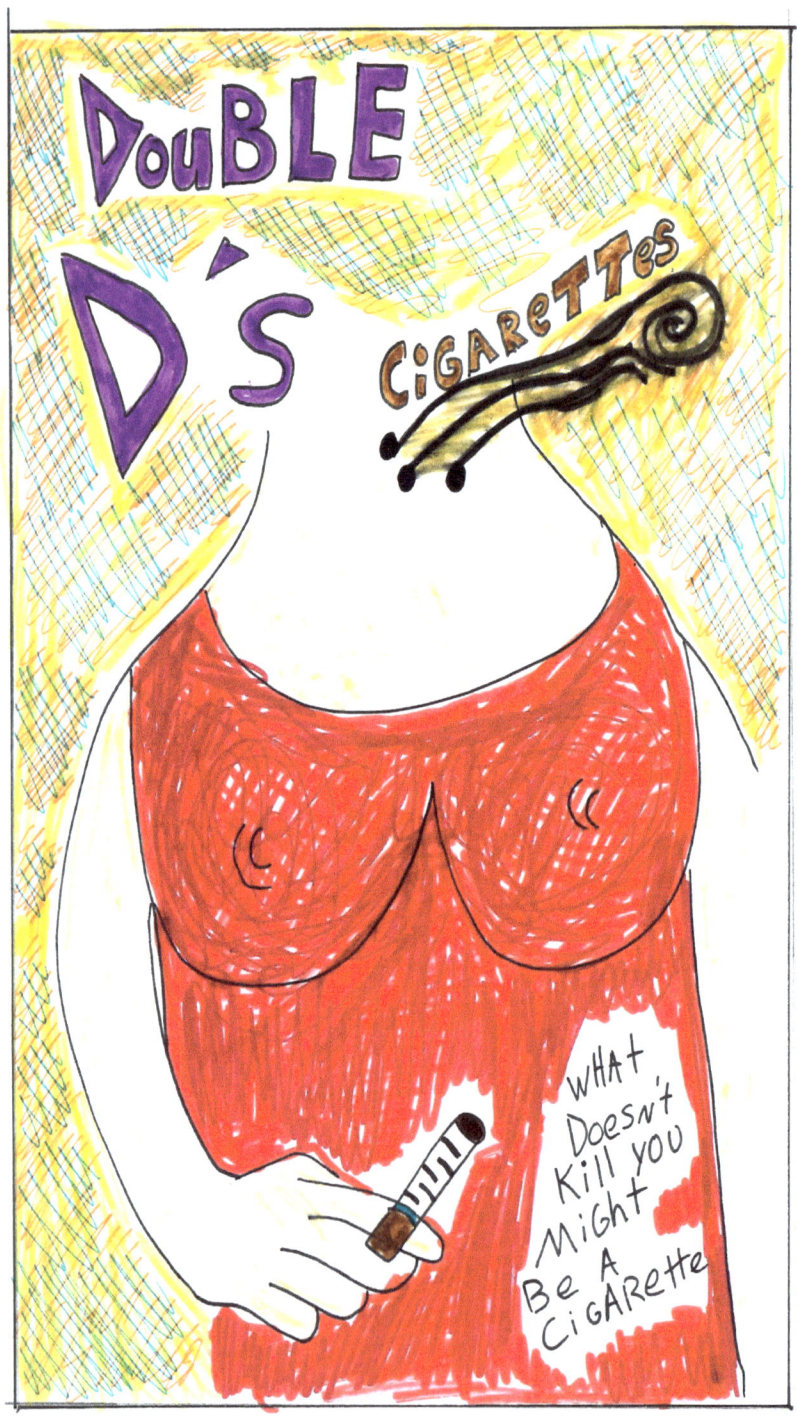

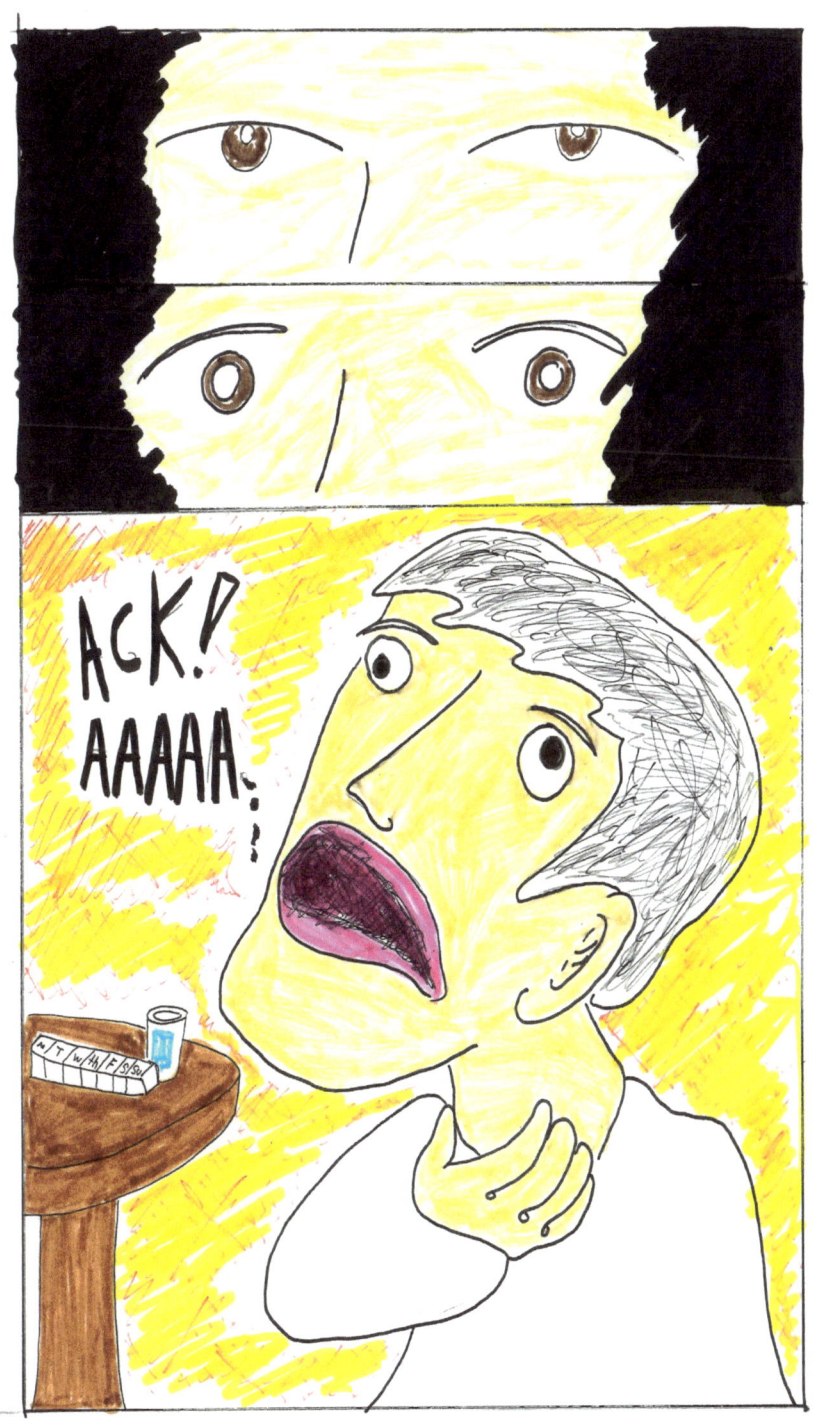

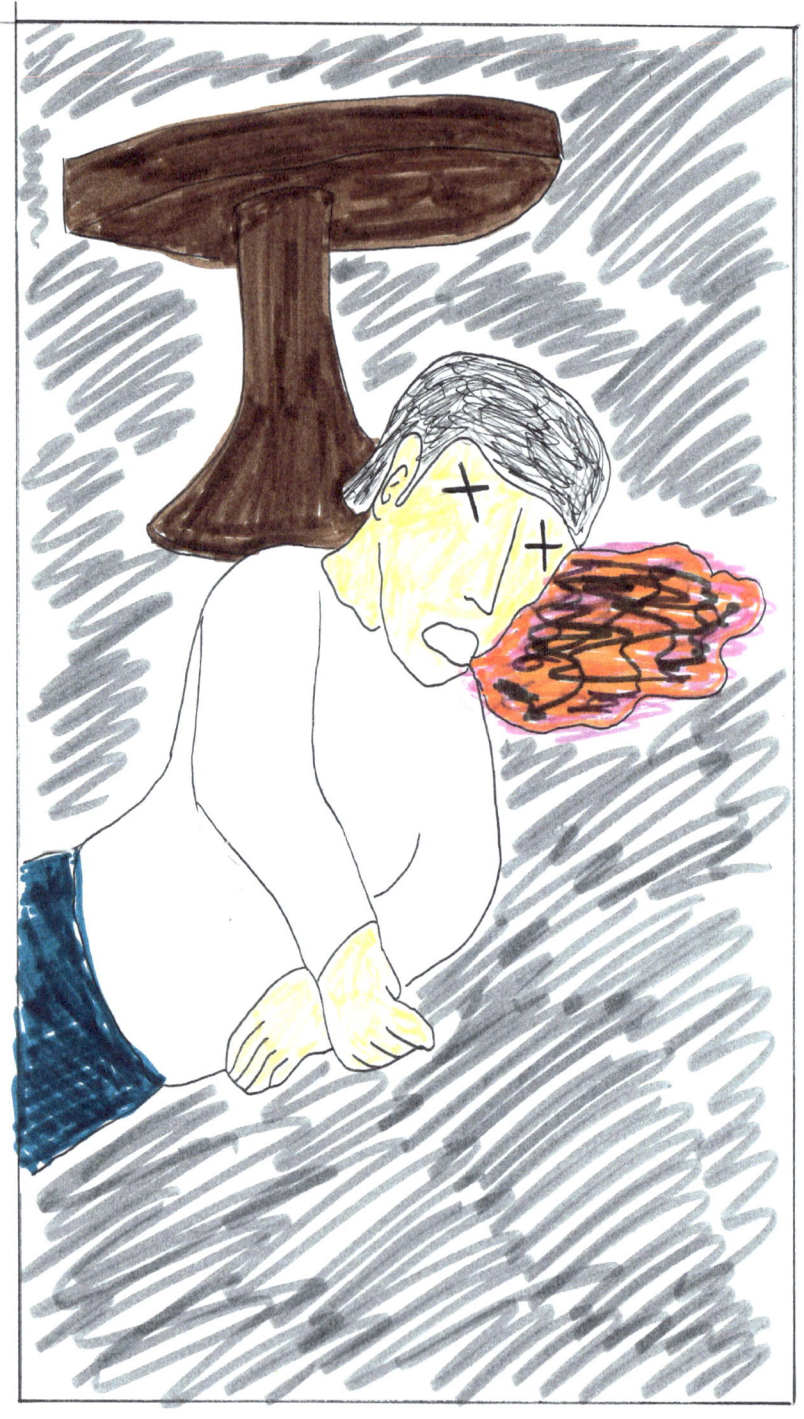

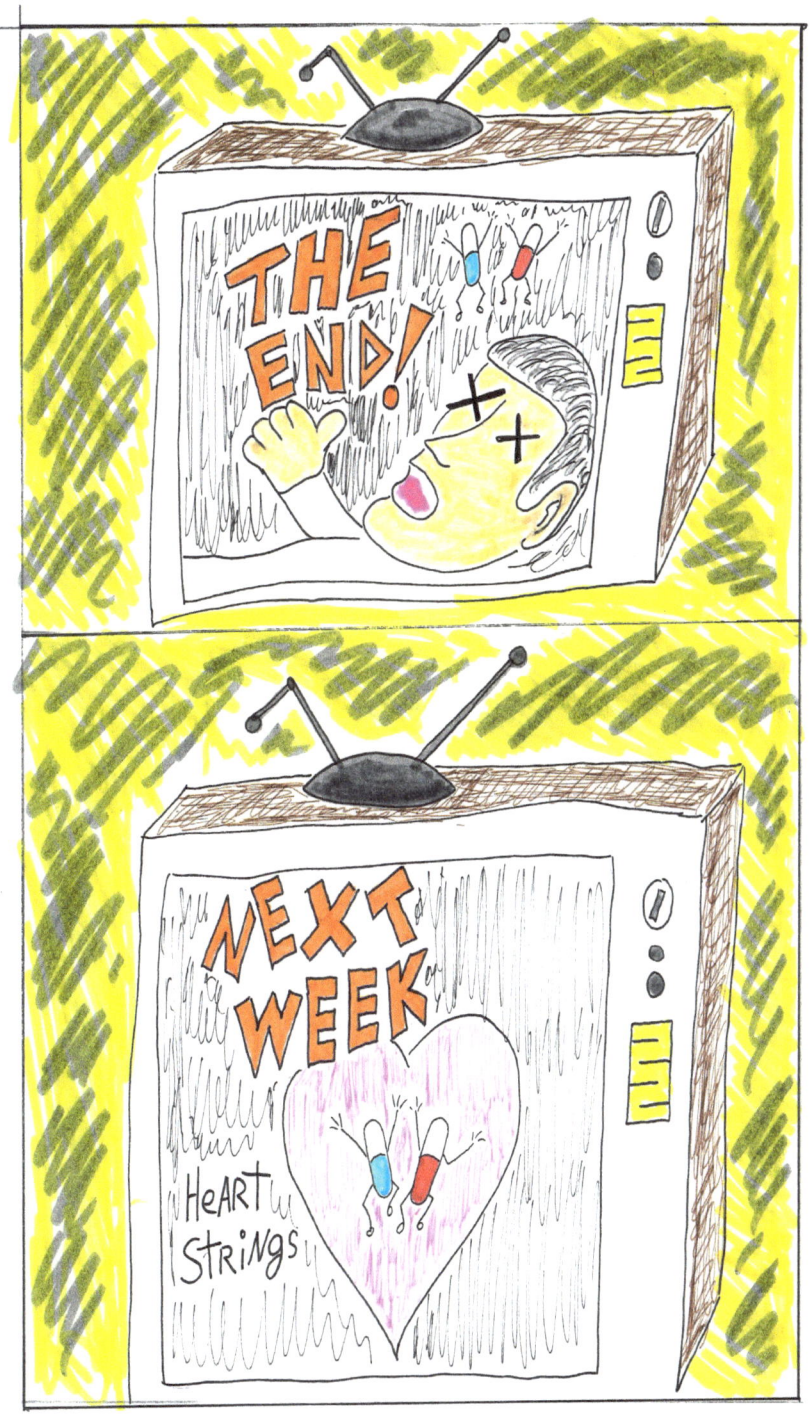

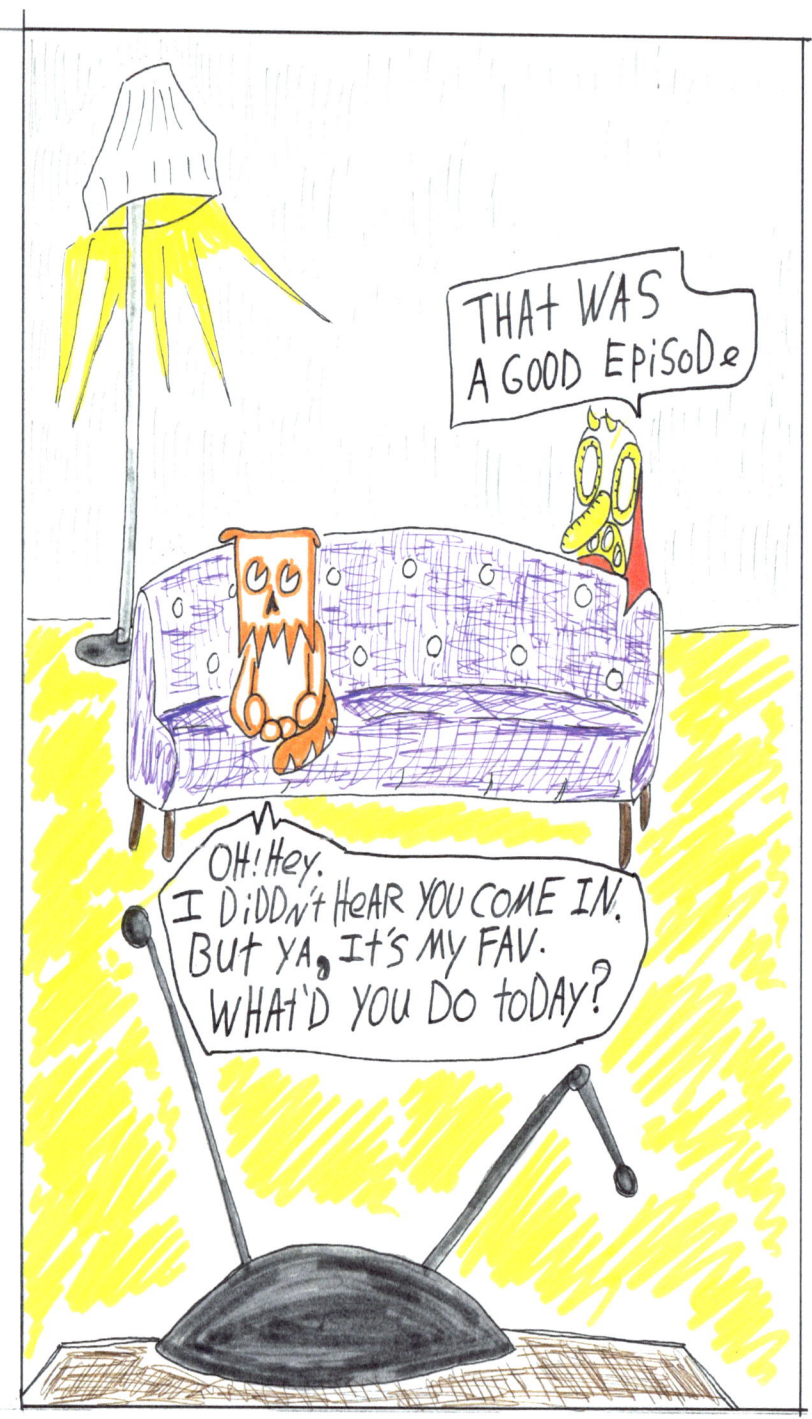

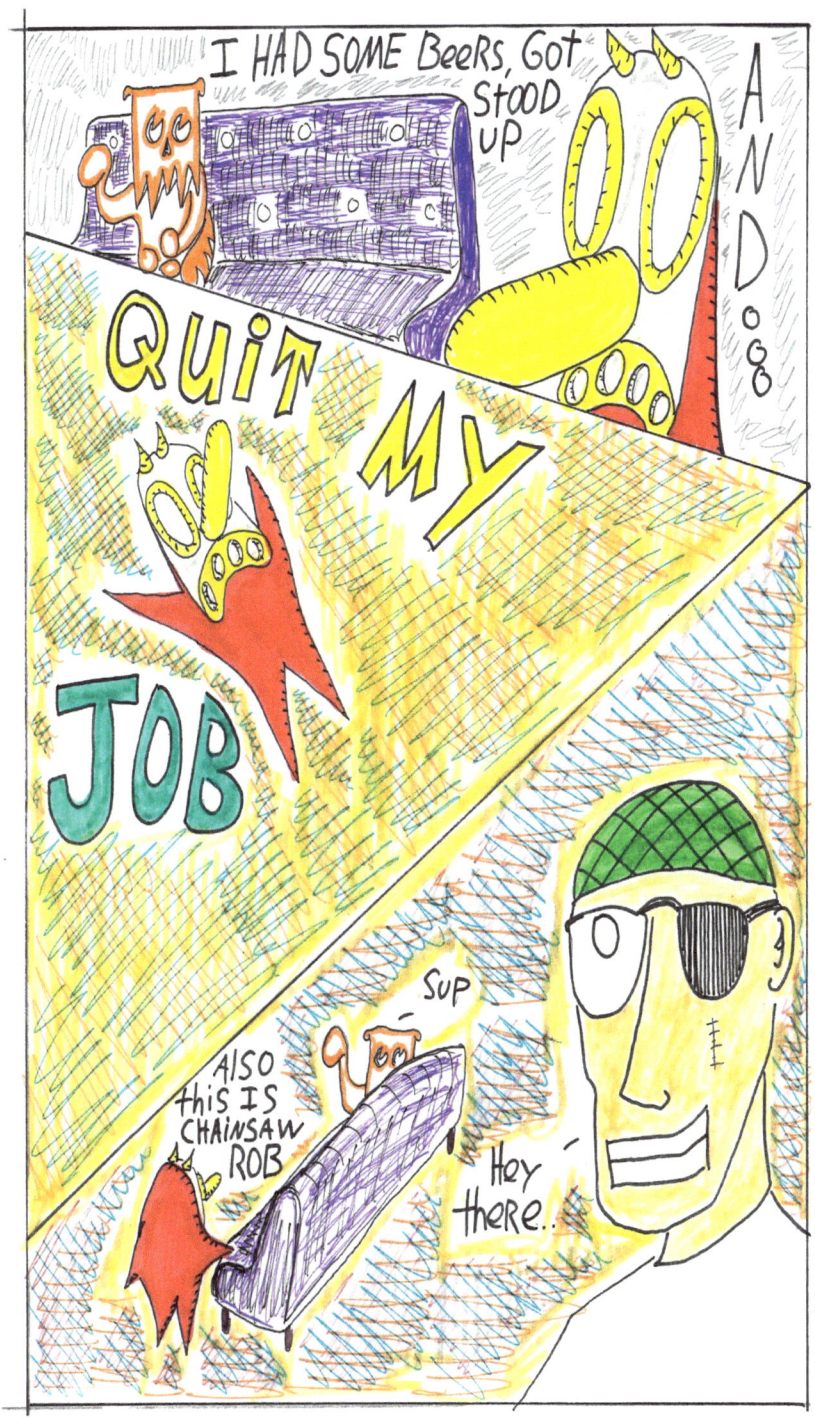

Dedicated to

Ethan A. Hahn and Crissy Cuellar

Without these two this would have probably never been made.

Love You Guys

A.F.

The answer is on page………….

www.ingramcontent.com/pod-product-compliance
Lightning Source LLC
Chambersburg PA
CBHW041114180526
45172CB00001B/242